D.G.
Rossetti

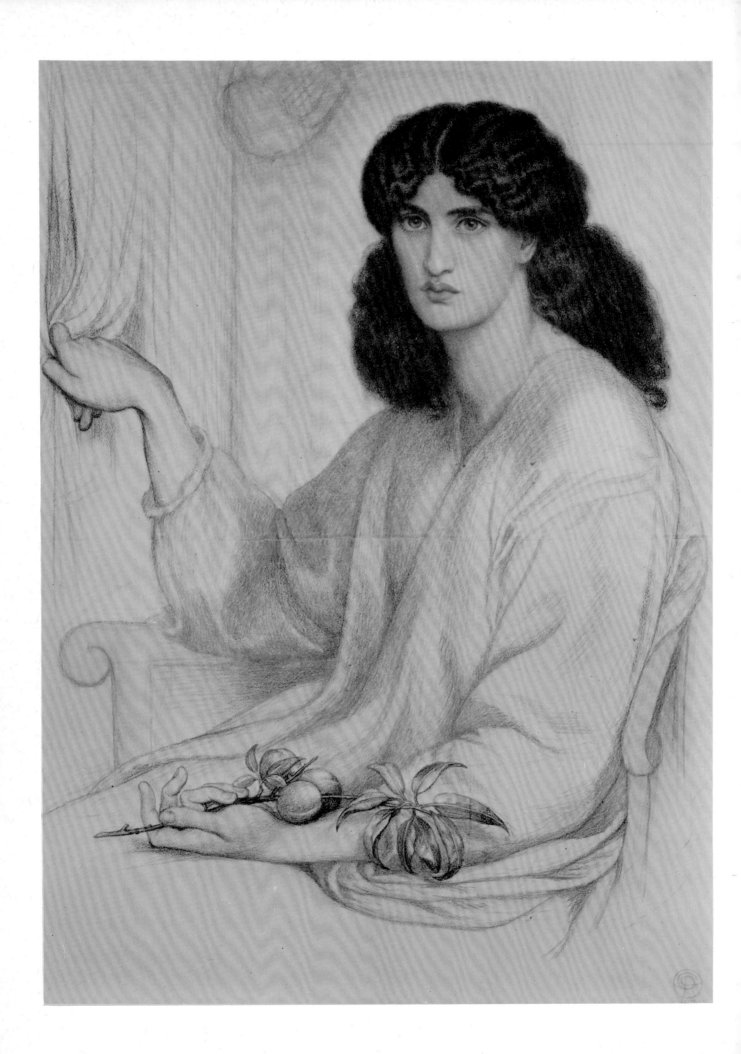

D.G. ROSSETTI

Marina Henderson

introduction by Susan Miller

academy editions : london

st.martin's press : new york

All Rossetti scholars and admirers are immeasurably indebted to Mrs. Virginia Surtees' *The Paintings and Drawings of Dante Gabriel Rossetti, A Catalogue Raisonné*, The Clarendon Press, Oxford, 1971, which has been invaluable in the compilation of this book. We would also like to thank the following museums and galleries for giving us permission to reproduce from their collections: The Tate Gallery, London *5, 11, 15, 19, 23, 25, 26, 29, 31, 33, 35, 43, 51, 52, 55, 60, 61, 62, 63, 64, 77, 79*; Birmingham City Museum and Art Gallery *22, 23, 24, 27, 34, 35, 37, 42, 55, 58, 59, 62, 76, 81, 98, 102*; The Faringdon Collection Trustees, Buscot Park *59, 86*; The Barber Institute of Fine Arts, University of Birmingham *95*; Ashmolean Museum, Oxford *9, 22, 70, 81*; Aberdeen Art Gallery and Museum *96*; The Trustees of the British Museum, London *7, 17, 48, 49*; The Fogg Museum of Art, Harvard University *32, 36, 45, 47, 53, 63, 65, 85, 93, 101*; Victoria and Albert Museum, London *71*, The University of Kansas Museum of Art, Lawrence, Kansas *90*; The Cecil Higgins Art Gallery, Bedford *13*; The Walker Art Gallery, Liverpool *33, 46*; The Syndics of the Fitzwilliam Museum, Cambridge *6, 14, 17, 21, 38, 43, 56, 68, 69, 82, 83, 92*; The Guildhall Art Gallery, London *97*; The Society of Antiquaries, Kelmscott Manor *10*; The Dean and Chapter of Llandaff Cathedral *40*; The Russell-Cotes Art Gallery and Museum, Bournemouth *87*; The Lady Lever Art Gallery, Port Sunlight *57*; Delaware Art Museum, The Wilmington Society of the Fine Arts, Wilmington, Delaware *66, 89, 99*; Manchester City Art Gallery *72, 78, 80, 84*; The National Museum of Wales, Cardiff *75*; The Brooklyn Museum, New York *Frontispiece*; Glasgow Art Gallery and Museum *67*; The William Morris Gallery, Walthamstow *50, 73*; The National Gallery of Canada, Ottawa *53*; Kunsthalle, Hamburg *91*.

We would also like to express our appreciation to Mr. Kenyur-Hodgkins of Sebastian d'Orsai Ltd., and to thank the following periodicals for allowing us to reprint articles: *The Spectator* for Rachel A. Taylor's "A King in Exile", May 1928; The *Burlington Magazine* for John Gere's "Pre-Raphaelites at the Tate", November 1948 and Roger Fry's "Rossetti's Water Colours of 1857", June 1916; and *Apollo* for "Current Shows and Comments", May 1948.

(Frontispiece) **Silence.** Black and red chalk, 41½″ × 31½″, 1870. (*The Brooklyn Museum, New York, gift of Mr. Luke Vincent Lockwood*)

A study of Jane Morris holding a branch of a peach tree; the fruit symbolizing the human heart, the leaf the human tongue.

First published in Great Britain in 1973 by Academy Editions,
7 Holland Street, London W.8

SBN 85670 022 3

First published in the U.S.A. in 1973 by St. Martin's Press Inc.
175 Fifth Avenue, New York, N.Y. 10010.
Affiliated Publishers: Macmillan & Company Limited London –
also at Bombay, Calcutta, Madras and Melbourne –
The Macmillan Company of Canada Limited, Toronto.

Library of Congress Catalogue Card Number: 72–97414

Designed by Prantong Jitasiri.
Printed in Great Britain by Burgess & Son (Abingdon) Ltd.
Bound in Great Britain by The Wigmore Bindery.

Introduction

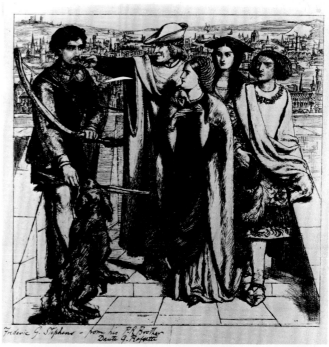

Taurello's First Sight of Fortune. Pen and brown ink. 10″ × 10¼″, 1849. (*The Tate Gallery, London*)

In 1824 Gabriel Rossetti, a renowned Italian revolutionary poet, arrived in London as a political exile. He became a professor of English at King's College and in 1826 married Maria Polidori, daughter of the translator of Milton and Lucan. The couple had four children: Maria (1827–76) who became an Anglican nun and author of a literary commentary *A Shadow of Dante*; Gabriel Charles Dante born on May 12, 1828; William Michael (1829–1919) critic, civil servant and Pre-Raphaelite historian and the poet Christina Georgina (1830–94).

The small house, 38 Charlotte Street off Portland Place, where the family lived was a centre for Italian refugees, some of them distinguished artists and scholars, who gathered in the evening to argue politics. But money was always short and Gabriel was a vague, distracted father directing all his energies to his massive study (it eventually filled five volumes) of Dante's work analysed according to a Freemasonic, anti-papal system which, he was convinced, would immediately bring about the downfall of Rome and of religion itself when it was published.

The children came to associate Dante with their mysterious father and were at once repelled and fascinated by the figure that obsessed him. The intellectual and ambitious Mrs. Rossetti encouraged her children to read and draw and when little Gabriel declared his ambition to be a painter his decision was calmly accepted. In 1837 William and Gabriel were enrolled in King's College School, where for four years Gabriel was a poor student, restless and bored, hating science and mathematics and sports. He and his brother took to exploring the streets and even then one can see him as a childish version of the man Ruskin was to describe as "A great Italian lost in the Inferno of London".

When Gabriel was thirteen his father allowed him to leave school to study art, hoping his son would be successful enough to support him in his old age. He entered the art school in Bloomsbury known as "Sass's" with very little education behind him, having successfully avoided any factual knowledge at King's, absorbing only what appealed to his imagination. His career at Sass's was hardly any more satisfactory, for here he rebelled against the emphasis on technique and left, after four years, without knowing that the human leg has more than one bone or the scientific elements of perspective. In 1848 he enrolled in the Antique School of the Royal Academy but there too he found rigorous discipline and dull technical exercises. At the Academy a student was trained according to a rigid programme, indoctrinated with a philosophy of art based on classical standards of beauty, requirements with little appeal to the romantic Rossetti. In his prose tale, *St. Agnes of Intercession,* he was later to tell his own story:

"As I became older, my boyish impulse towards art grew into a vital passion, till at last my father took me from school and permitted me my own bent of study. The beginnings of Art, entered on at all seriously, present an alternation of extremes: on the one hand, the most bewildering phases of mental endeavour, on the other, a toil rigidly exact and dealing often with trifles. What was then the precise shape of the cloud within my tabernacle, I could scarcely say now; or whether through so thick a veil I could be sure of its presence there at all. And as to which statue at the Museum I drew most or learned least from, – or which Professor at the Academy 'set' the model in worst taste, – these were things which no-one need care to know. I may say, briefly,

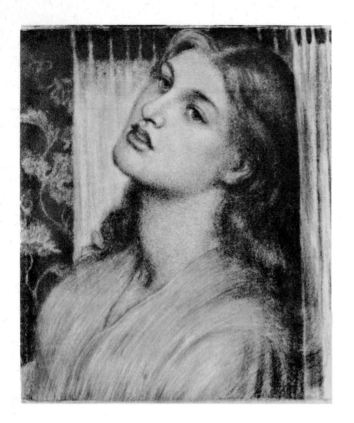

Study for **La Belle Dame Sans Merci.** Pencil, pen and wash, 13″ × 17″, c. 1855. (*The British Museum, London*)

◀

Study for **La Pia de'Tolemei.** Red, white and black chalk, 18″ × 14″, 1868. (*The Fitzwilliam Museum, Cambridge*)

that I was wayward enough in the pursuit, if not in the purpose; that I cared even too little for what could be taught me by others; and that my original designs greatly outnumbered my school-drawings."

Surrounded at the Academy by admiring friends the legend of Gabriel's personal magnetism was beginning to take shape, and despite his lack of actual achievement, he developed a reputation as a gifted, inspired student. Frustrated at school and impatient to begin a career, he considered turning seriously to poetry, which he hoped would not require the mastery of detail he found so discouraging in painting. His dreams of instant success were encouraged by the poverty of his family and his life-long vacillation between poetry and painting had begun. In 1848 he left the Academy School in a gesture of independence, determined to shape his own future.

The atmosphere at the Academy that Rossetti found so stultifying reflected the materialistic and scientific pre-occupations of the period when, according to Carlyle, "The truth is, men have lost their belief in the Invisible, and believe, and hope, and work only in the Visible or, to speak of it in other words: This is not a religious age. Only the material, the immediately practical, not the divine and spiritual, is important to us . . ."

Rossetti appealed to three men in his search for relief from the tedium of established education. The first was William Bell Scott, whose poems Rossetti admired. Scott visited the hopeful poet but was unable to remain in London to be his teacher. In 1848 Rossetti wrote to the little-known painter, Ford Madox Brown, whose work he had seen four years before in an exhibition of designs for the new Houses of Parliament. His letter was so enthusiastic that the unsuccessful Brown came to see him armed with a stick to punish the cruel joker. When faced with Rossetti's evident sincerity Brown agreed to take him on as a pupil, free of charge, and Rossetti joined him in his Clipstone Street studio. Despite eventual difficulties in the teacher-apprentice relationship the two were to remain close friends. Rossetti believed in Brown's talent steadfastly all his life and always referred to him questions of difficult composition and technique. His daring choice of Brown as a teacher is an indication of his unusual ability to recognize talent, of the same adventurous perception that led him, when still a student, to purchase a notebook of Blake's, then considered unimportant enough to be had for a few shillings. Rossetti next appealed to Leigh Hunt, sending his poems and asking for advice. He was, Hunt replied, "an unquestionable poet" but warned him that even a popular poet had a much smaller chance of financial success than a painter, a consideration of some importance to Rossetti.

At Brown's studio Rossetti benefited from the artist's solid intellectual understanding of design and from the chance to paint from living models instead of Academy casts. But he simply could not paint the still lifes, the "pickel jars" that Brown, as much of a disciplinarian as an Academy instructor, set up as exercises. His next teacher, Holman Hunt, had also been a student at the Academy but the two young artists had not met until Rossetti, a great admirer of Keats, saw Hunt's painting *The Eve of St. Agnes* at the

1848 Royal Academy Exhibition. Like Brown, Hunt believed in a fresh and faithful approach to natural detail, to be achieved through personal observation. He was, as he explained in his autobiography, *Pre-Raphaelitism and the Pre-Raphaelite Brotherhood*, ". . . putting in practice the principle of rejection of conventional dogma, and pursuing that of direct application to Nature for each feature, however humble a part of foreground or background this might be . . . I justified the doing of this thoroughly as the only sure means of eradicating the stereotyped tricks of decadent schools, and of any conventions not recommended by experienced personal judgement." Rossetti soon moved into Hunt's studio, No. 7 Cleveland Street, where he began to paint his first real project in oils, *The Girlhood of Mary Virgin*. Hunt was able to bring his friends Millais and Rossetti to share in his disgust with the art of Raphael and his successors, although Rossetti's conversion owed more to his eagerness to rebel against the hated Academy than to any strong belief in the principles of "Pre-Raphaelite detail". At the same time Brown was busy praising the austere religious style of the German Pre-Raphaelites, the Nazerenes, a contemporary group of artists led by Cornelius and Overbeck. The great confusion that ensued over which doctrine was to be followed by the English rebels, recently formed into a Brotherhood, is described by Hunt in his account of the meeting in which they attempted to settle on a name: "In my own studio, soon after the initiation of the Brotherhood, when I was talking to Rossetti about our ideal intention, I noticed that he still retained the habit he had contracted from Ford Madox Brown, of speaking of the new principles of art as 'Early Christian'. I objected to the term as attached to a school as far from vitality as was modern classicalism, and I insisted upon the designation 'Pre-Raphaelite' as more radically exact, and as expressing what we had already agreed should be our principles. The second question, what our corporation itself should be called, was raised by the increase of our company. Gabriel improved upon previous suggestion with the word Brotherhood, over-ruling the objection that it savoured of clericalism. When we agreed to use the letters P.R.B. as our insignia, we made each member solemnly promise to keep its meaning absolutely secret, foreseeing the danger of offending the reigning powers of the time."

The seven members of the P.R.B. were Rossetti, Hunt, Millais, William Michael Rossetti, Thomas Woolner, Frederic George Stephens and William Collinson, Brown having declined the invitation to join. The closest the group ever came to unity was during a September meeting at Millais's studio, where they examined a book of frescoes of the Campo Santo at Pisa and reached a general sort of agreement that their own designs should aim at similar freshness, innocence and imagination. But the serious, religious Hunt and the highspirited, irresponsible Rossetti began to quarrel and, as soon as he had finished *The Girlhood of Mary Virgin*, Rossetti moved out of Hunt's studio. The painting had been intended for the Royal Academy Exhibition but at the last minute, fearful of the criticism its technical inadequacy would arouse, Rossetti decided to hang it at the Free Exhibition at Hyde Park Corner, where space could be bought by any artist who wished to show his work. Rossetti's aunt, Charlotte Lydia Polidori,

arranged for the sale of the painting, which had received some praise from the critics, to the Marchioness of Bath, from whom the shrewd Rossetti extracted an extra £20 and after this triumph he set off on a European tour with Hunt. They visited galleries and museums but were largely indifferent or even hostile to the things they saw, apart from the Memlings and Van Eycks at Bruges, which excited Rossetti so deeply that he wrote to Collinson, addressing him as "Dear P.R.B. . . . I shall not attempt any description. I assure you that the perfection of character and even drawing, the astounding finish, the glory of colour, and above all the pure religious sentiment and ecstatic poetry of these works, is not to be conceived or described. Even in seeing them, the mind is at first bewildered by such Godlike completeness; and only after some while has elapsed can at all analyse the causes of its awe and admiration; and then finds these feelings so much increased by analysis that the last impression left is mainly one of utter shame at its own inferiority."

When Hunt and Rossetti returned to London the meetings of the Brotherhood continued. Several other writers and artists like Walter Howard Deverall, Arthur Hughes and Coventry Patmore were recruited by the original seven to help launch Rossetti's project, *The Germ*, intended to be the Pre-Raphaelite journal. Although its life of four issues was brief and financially disastrous the review did attract the attention of some critics. In it were published a revised version of Rossetti's important early poem *The Blessed Damozel* and his significant prose story *Hand and Soul*. In the romantic *Hand and Soul*, the soul of the artist hero Chiaro appears to him in the form of a beautiful woman: "A woman was present in his room, clad to the hands and feet with a grey and green raiment, fashioned to that time. It seemed that the first thoughts he had ever known were given him as at first from her eyes, and he knew her hair to be the golden veil through which he beheld his dreams . . . As the woman stood, her speech was with Chiaro . . . 'I am an image, Chiaro, of thine own soul within thee. See me, and know me as I am . . . Chiaro, servant of God, take now thine Art unto thee, and paint me thus, as I am, to know me . . . Do this, so shall thy soul stand before thee always, and perplex thee no more." These instructions Rossetti was to obey throughout his life seeking, in the many portraits of women he painted, to reveal his own soul. The rift between the realistic and the romantic Pre-Raphaelites was growing deeper and as a result no clear statement of their aims ever appeared in *The Germ*. In 1850 the artists who had exhibited their work at the Royal Academy Exhibition were met with violent attack from established critics, who had by now discovered the meaning of the three mysterious initials and who felt deeply threatened by the idea of an organized group of rebellious artists. That all the painters had been students of the Academy and that, in a band, they could defy the ultimate taste-making body of the day, was not to be endured. *The Athenaeum* cried, "Abruptness, singularity, uncouthness, are the counters by which they play for game. Their trick is to defy the principles of beauty and the recognized axioms of taste. (They) set at nought all the advanced principles of light and shade, colour and composition – these men, professing to look only to Nature in its truth and simplicity, are the slavish imitators of artistic inefficiency", the last statement not altogether untrue as far as Rossetti was concerned. The attack continued with force for the next two years and the Brotherhood, already suffering from inner quarrels, was weak and discouraged. In desperation Patmore approached John Ruskin, whose *Modern Painters* had influenced the P.R.B. To please Patmore, Ruskin, then at the height of his fame, published two letters in *The Times*, in May, 1851, in defence of the Brotherhood. In his eloquence he gave them an aesthetic creed which they did not as a group actually possess, proclaiming them painters of "archaic honesty" rather than "archaic art". The intensity of critical abuse that had been heaped on the Pre-Raphaelites had given them a certain notoriety which now worked to their advantage. With the sanction of an established art critic they became almost as respectable as Ruskin himself, and Hunt and Millais set their sights on the once detested Academy.

By this time Rossetti was already deeply involved with Elizabeth Siddal. Deverall had discovered her in a milliners, where she was a shop assistant, in 1850 and she soon became a favourite Pre-Raphaelite model, sitting for Hunt and for Millais's *Ophelia*. Eventually she sat only for Rossetti, and her face and figure and heavy red-gold hair became established as the Pre-Raphaelite image of beauty.

She was seventeen when Rossetti met her, he was twenty-three and believed he had found in her the "image of his soul". He moved to 14 Chatham Place, Blackfriars, which was to be his home until her death in 1862, and there he encouraged her to paint and write. Her character remains extremely vague, despite her long relationship with Rossetti and the number of people who knew her. According to some reports she was witty, intelligent, charming and kind. To others she seemed dull, vague and bitterly selfish, completely unworthy of Rossetti, and not even very beautiful. Yet the role she was expected to fulfil was one whose requirements were conflicting. She existed for Rossetti as an image of his soul, her famous hair "the golden veil through which he beheld his dreams." He dreamed of living the love that had been only symbolic for Dante, and to paint those dreams which he saw reflected in the one he loved. He idealized what he saw in the mirror of his soul, transforming the real into the ideal in both his life and his art, requiring her to be both a physical lover and an unattainable dream, but always an extension of himself. Her illness was her one control over him, an illness as mysterious as everything else about her, and through it she forced him to concede to reality as far as was possible. She was ill when they met and her condition, which was never diagnosed with any more accuracy than Dr. Ackland's strange "mental power too long pent-up and lately over-taxed", was to grow steadily more acute. During the first years at Chatham Place they were totally absorbed with each other, Rossetti drawing endless portraits of her and becoming more

Study for **Sir Launcelot's Vision of The Sanc Grael.** Water-colour, 26¾″ × 40¾″, 1857. (*Ashmolean Museum, Oxford*)

and more possessive. Brown tells how Rossetti showed him "a drawer full of 'Guggums'. God knows how many, but not bad work, I should say, for the six years he had known her; it is like a monomania with him." Rossetti was worried and depressed by the state of her health, yet never allowed her to go into hospital. In July, 1854 he wrote to William Allingham: "For my own part, the more I think of the B[rompton] H[ospital] for her, the more I become convinced that when left there to brood over her inactivity, with images of disease and perhaps death on every side, she could not but feel very desolate and miserable. If it seemed at this moment urgently necessary that she should go there, the matter would be different; but Wilkinson says that he considers her better. I wish, and she wishes, that something should be done by her to make a beginning, and set her mind a little at ease about her pursuit of art, and we both think this more than anything would be likely to have a good effect on her health. It seems hard to me when I look at her sometimes, working or too ill to work, and think how many without one tithe of her genius or greatness of spirit have granted them abundant health and opportunity to labour through the little they can do or will do, while perhaps her soul is never to bloom nor her bright hair to fade, but after hardly escaping from degradation and corruption, all she might have been must sink out again unprofitably in that dark house where she was born. How truly she may say, 'No man cared for my soul.' I do not mean to make myself an exception, for how long have I known her, and not thought of this till so late – perhaps too late. But it is no use writing more about this subject; and I fear, too, my writing at all about it must prevent your easily believing it to be, as it is, by far the nearest thing to my heart."

Absorbed as he was in his personal life, Rossetti grew more remote from the P.R.B. He had not made one sale since *The Girlhood of Mary Virgin* until 1853 when MacCracken, a shipping agent, bought *Ecce Ancilla Domini* for 50 guineas. MacCracken was typical of most of Rossetti's patrons, men who bought art for its financial and not aesthetic value. Rossetti resented the artist-patron relationship, felt his life to be ruled by the whims of his buyers and never hesitated to cheat or fool them as far as "tin" was concerned. In 1873, at a time when his paintings were bringing in high prices, he wrote to Brown, "I have often said that to be an artist is just the same thing as to be a whore, as far as dependence on the whims and fancies of individuals is concerned. The natural impulse is to say simply – Leyland be d–d! and so no doubt the whore feels but too often incline to say and cannot.'

9

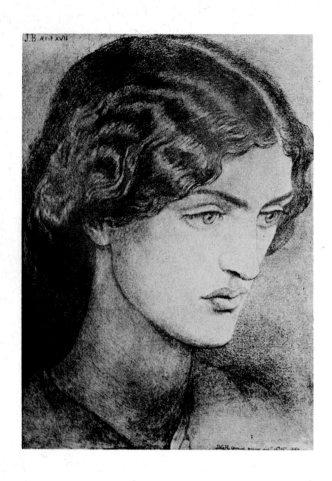

Mrs. William Morris. Pencil, 18¾″×13″, 1857.
(*The Society of Antiquaries, Kelmscott Manor*)

But in 1853 all that Rossetti was painting, and occasionally selling, were watercolours, with themes taken from Dante and mediaeval legends, painted in the rich, bright colours of mediaeval illuminated manuscripts. His skill as a colourist had been encouraged by the Pre-Raphaelite philosophy, and he adopted their practice of applying colour to wet white ground in order to achieve the luminous effect of stained glass. This innovation, which brought the trend away from the dark canvases of the early 19th century to a culmination, was an extension of the Pre-Raphaelite philosophy of "truth to nature". Instead of a gradual darkening proceeding out from a single source of light, the Pre-Raphaelites, and Ruskin, believed that all objects should be painted as if under the light of the sun, each individually lit and casting its own shadow. Rossetti believed colour to be of utmost importance in painting and indeed his extraordinary use of it is often the most beautiful aspect of his work. In May 1854 he wrote to Francis MacCracken: "I believe colour today to be a quite indispensible quality in the highest art, and that no picture ever belonged to the *highest* order without it: while many by possessing it – as the works of Titian – are raised certainly into the highest *class*, though not to the very highest grade of that class, in spite of the limited degree of their other qualities . . . Colour is the physiognomy of a picture, and like the shape of the human forehead, it cannot be perfectly beautiful, without proving goodness and greatness. Other qualities are its life exercised, but this is the body of its life, by which we know and love it at first sight." But the romantic paintings of Rossetti had few other affinities with the realistic work of the other Pre-Raphaelites, who believed their art, like the novels of Dickens, could act as a force of moral good.

Despite Ruskin's strict belief in the close observation of nature he found much to admire in Rossetti's work, telling him in 1854 that he thought *The First Anniversary of the Death of Beatrice* "a thoroughly glorious work", and asking his permission to come to Chatham Place. Ruskin "discovered" Rossetti at a very fortunate time, when Rossetti was poor, unknown and discouraged, and painting only erratically. Ruskin praised Elizabeth Siddal's work, gave them money and support trying to assure them, as far as he could, of success. Rossetti probably began painting *Found* to please Ruskin and, significantly, it was never completed. Ruskin wanted Gabriel to marry Elizabeth Siddal, hoping that, once domesticated, he would work more conscientiously. Like most of Ruskin's plans for them this one failed, although why Rossetti was so reluctant to marry her is unclear. Both she and Rossetti protested against Ruskin's control. After years of increasing strain, bitterness and misunderstanding, when Rossetti was established as a prominent artist, their relationship came to an end.

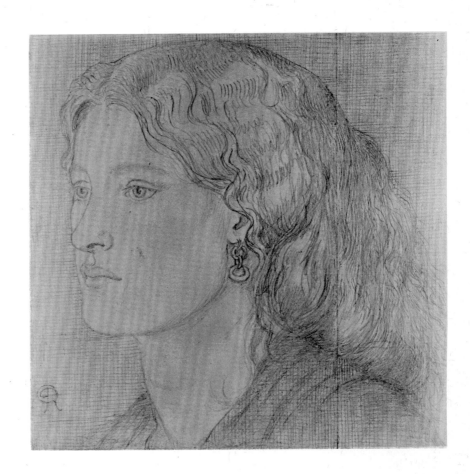

Fanny Cornforth. Pencil, $5\frac{5}{8}'' \times 5\frac{3}{4}''$, 1859. (*The Tate Gallery, London*)

In 1854 Ruskin was asked to teach drawing at the Working Men's College, an educational experiment founded by the socialist F. D. Maurice. Here he was free to teach according to his revolutionary theory of "sight", through which he hoped the "Innocence of the eye" might be regained. He recruited Rossetti into the project who taught there until 1858. Rossetti's method of teaching was as unstructured as Ruskin's was methodical and rigorous. He often did not appear for classes and ignored the technical problems that he himself never mastered. But he had a lasting impact on his students, who were deeply impressed and inspired by his devotion to art. Largely because of Ruskin, Rossetti was gaining a reputation as the "leader" of the Pre-Raphaelites. He turned more and more in the direction of poetic painting, which he emphasized by attaching sonnets to the frames of his picture, illustrating his paintings with poems in a reversal of the usual attitude. His old dilemma of choosing between poetry and painting found temporary resolution in this and he said ". . . if a man has any poetry in him he should paint, for it has all been said and written, and they have hardly begun to paint it." He realized that the limitations of his energy and perseverance made it necessary for him to focus on one art, as he confided to William Allingham in August, 1854 " . . . I believe my poetry and painting prevented each other from doing much good for a long while – and now I think I could do better in either, but can't write, for then I sha'n't paint." Most of the money he earned was for canvases like *Paolo and Francesca di Rimini*, which he did in a week to pay for a trip to Paris. His habit of spending money for clothes and holidays, when forced to borrow money in order to eat, infuriated Ruskin. Yet it was, in a sense, necessary for Rossetti to keep himself in a state of dire poverty, of ever-impending emergency, in order to find the impetus to paint. Ruskin knew he was losing control over the situation and desperately announced "I never, so long as live, will trust you to do anything out of my sight."

The original Brotherhood had been gradually breaking up since 1850 when Collinson, a devout Catholic, defected for religious reasons. In 1852 Woolner, discouraged with art, left for Australia. In 1854 Millais was made an Associate of the Royal Academy and no longer needed the Brotherhood. Hunt left for Palestine, where he remained for 12 years and their "leader", Rossetti, had long since been estranged from them. In 1856–57 Rossetti found himself the inspirational force to a new and younger group of artists, including Burne-Jones and Morris, then undergraduates at Oxford. There, independent of any knowledge of the London Brotherhood, they had become engrossed in mediaevalism, had read Tennyson, the Romantic poets and had organized an informal Oxford Brotherhood. They read Ruskin's Edinburgh Lectures, in which Rossetti was praised, and, when they saw his painting

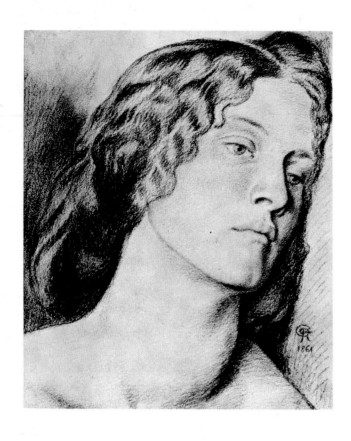

Study for **Fair Rosamund.** Coloured chalks, 12½″ × 10″, 1861. (*The Cecil Higgins Art Gallery, Bedford*)

The First Anniversary of the Death of Beatrice, he became their idol. Burne-Jones sought him out at the Working Men's College, filled with awe and reverence, "I was two and twenty and had never met, or even seen a painter in all my life. I knew no-one who had ever seen one, or had been in a studio, and of all the men that lived on earth, the one that I wanted to see was Rossetti. I had no dream of knowing him, but I wanted to look at him, and I had heard that he taught at the Working Men's College". Flattered, and sharing their nostalgic spirit, Rossetti guided them both to painting and encouraged Morris to write poetry. They published *The Oxford and Cambridge Magazine*, through which Rossetti's poetry found a larger audience than ever before. Delighting in the admiration Rossetti told William Allingham that the person responsible was " . . . a certain youthful Jones, who was in London the other day, and whom . . . I have now met. One of the nicest young fellows in Dreamland. For there most of the writers in that miraculous piece of literature seem to be." Drawn to London by Rossetti's presence Burne-Jones and Morris took the rooms in Red Lion Square that had once been shared by Deverall and Rossetti and there set about creating an environment which would make their "dreamland" real, decorating the furniture with scenes from Dante and their favourite mediaeval tales. Their idealism revived Rossetti's fading dreams and Morris gave up his architectural practice to write and paint. They lived in their own world of fable and romance, completely happy and devoted to Rossetti. Burne-Jones was to recall that year as one "in which I think it never rained, nor clouded, but was blue summer from Christmas to Christmas, and London streets glittered, and it was always morning, and the air sweet and full of bells."

In the summer of 1857, enthusiastic about creating an artistic environment, Rossetti convinced his friend, the architect Benjamin Woodward, that the walls of the Debating Society Hall in the new Oxford Union should be decorated with a series of mediaeval murals. Calling Burne-Jones and Morris up from London they were joined in Oxford by John Hungerford Pollen, Spencer Stanhope, Val Prinsep and Arthur Hughes, and the "Jovial Campaign" was launched. As Prinsep recalled, Rossetti was the centre of the group, "the planet around which we revolved. We copied his way of speaking. All beautiful women were 'stunners' with us . . . Mediaevalism was our *beau ideal*, and we sank our own individuality in the strong personality of our adored Gabriel." The project, which was never completed, consisted of 10 paintings, each illustrating some section of the *Morte d'Arthur*, Rossetti's contribution being *Sir Launcelot's Vision of the Sanc Grael*. The artists cheerfully proceeded without any knowledge of fresco technique and within six months all the paint had either sunk into or flaked off the damp plaster, until only a trace of their work remained.

To the Victorians the mediaeval city of Oxford was the symbol of all their nostalgic yearnings. For the second group of Pre-Raphaelites it was as Matthew Arnold had described it, "And yet, steeped in sentiment as she lies, spreading her gardens to the moonlight, and whispering from her towers that last of the Middle Ages, who will deny that Oxford, by her ineffable

charm, keeps ever calling us nearer to the true goal of all of us, to the ideal, to perfection, – to beauty, in a word, which is only truth seen from another side?" It was in Oxford that the direction of the second phase of Pre-Raphaelitism took shape. Like the Romantic poets they so admired, these artists believed in the truth of the inner version, but their introspection did not find correspondences in the contemporary world. They retreated into a self-contained mediaeval dream, growing more and more remote from the realities of their own society. The "art for art's sake" philosophy of the Aesthetic movement had its roots in this detachment, which Pater described in "Conclusion": "Experience, already reduced to a group of impressions, is ringed around for each one of us by that thick wall of personality through which no real voice had ever pierced on its way to us, or from us to that which we can only conjecture to be without. Every one of those impressions is the impression of the individual in his isolation." They lived in an atmosphere much like Smetham's description of Rossetti's *The Wedding of St. George and the Princess Sabra*, painted in 1857: " . . . like a golden dim dream . . . love 'credulous all gold', gold armour, a sense of secret enclosure in 'palace chambers far apart' – quaint chambers in quaint palaces where angels creep in through sliding panel-doors, and stand behind rows of flowers, drumming on golden bells, with wings of crimson and green." The one reality in their own world was women. Their beauty was the Pre-Raphaelite religion and a "stunner" had to be unquestionably admired and exalted. At Oxford Rossetti discovered Jane Burden, who modelled for his panel in the Union. He fell in love with her but, still tied to Elizabeth Siddal, suggested that Morris, who worshipped her, should marry her, so that she could be kept within their circle. Rossetti picked up another disciple that summer in Oxford, Algernon Charles Swinburne, then an undergraduate at Balliol, who was drawn to the sensual and mysterious atmosphere surrounding the Pre-Raphaelites.

In 1857 Rossetti was asked to contribute designs to the Moxon edition of Tennyson's poems. He chose for his themes *The Vision of Sin* and *The Palace of Art*, subjects, he said "where one can allegorize on one's own hook." Tennyson himself did not approve of Rossetti's designs, but they were instrumental in making Rossetti known to the public. A free Pre-Raphaelite exhibition was held in the same year, and it was clear that the critics had revised their opinion of the Brotherhood. The *Saturday Review* noted that Rossetti's "somewhat numerous contributions unquestionably constituted the main interest of the exhibition." Nevertheless he was always desperately short of money and constantly sought out new buyers and produced replicas in order to obtain cash quickly. His refusal to marry Elizabeth Siddal was the cause of more frequent and violent quarrels. She was no longer his only model and he painted Jane Morris, Fanny Cornforth, Ruth Herbert and others, having abandoned Beatrice for Guinevere and for luxuriously clad exotic figures. The Llandaff triptych, begun in 1860 was executed, as Holman Hunt said " . . . at the turning point from his first severity of style to a sensuous manner." For the first time in nine years he took up oils, more lucrative and respectable than water colour, and to succeed in that medium became his greatest ambition. He had to overcome his many technical deficiencies as well as his impatience, and chose to paint single figures in as controlled a setting as he could manage. To William Bell Scott, in 1859, he wrote that he had "painted a half figure in oil . . . I am sure that among the many botherations of a picture where design, drawing, expression, and colour have to be thought of all at once (and this, perhaps, in the focus of the four winds out of doors, or at any rate among somnolent models, ticklish draperies, and toppling lay figures), one can never do justice even to what faculty of mere painting may be in one. Even among the old good painters, their portraits and simpler pictures are almost always their masterpieces for colour and execution . . . far more than anything done I have been struggling in a labyrinth of things which it seems impossible to get on with, and things which it seems impossible to begin."

In the spring of 1860 Elizabeth Siddal was critically ill and Rossetti, afraid for her life, at last agreed to marry her. After the wedding in May 1860 at St. Clements Church, Hastings, they left on a three-week honeymoon in Paris. Once back in London their life together continued to be oppressive to them both. She was still ill and was taking laudanum to relieve the pain. In May 1861 she delivered a still-born child and her depression became acute. Rossetti was busy helping Gilchrist edit his Blake manuscript and with the publication of his own book of translations *The Early Italian Poets together with Dante's Vita Nuova* which despite critical approval was not a popular success. He designed stained glass for William Morris's firm, Morris, Marshall, Faulkner and Co., in which Rossetti was a formal partner. His oils were beginning to sell and his habitual artistic frustration seemed to be easing. On February 10, 1862 he dined with his wife and Swinburne at a restaurant in Leicester Square, took Lizzie home and went out again. When he returned later that night he found her unconscious and within a few hours she was dead from an overdose of laudanum.

Although the verdict at the inquest was accidental death the obvious possibility that his wife had committed suicide haunted Rossetti for the rest of his life. He secretly placed the only manuscript of his poems in her coffin and they were buried with her, a dramatic gesture exactly paralleling the events of a story his sister Christina had written twelve years before. In October 1862 he moved to Tudor House, 16 Cheyne Walk, and there the isolation that characterized his art took over his life. He installed his model, Fanny Cornforth, as housekeeper and employed art assistants to help him complete the replicas and "pot-boilers" he was forced to do to pay his heavy debts. He amassed a huge collection of blue and white china, mirrors, rich fabrics and jewels, spending hours in junk shops and sales. He collected animals, filling Tudor House with wombats, peacocks, kangaroos and salamanders and even an Indian Bull, purchased, it is said, because it had eyes like Jane Morris. He saw few people, refused to

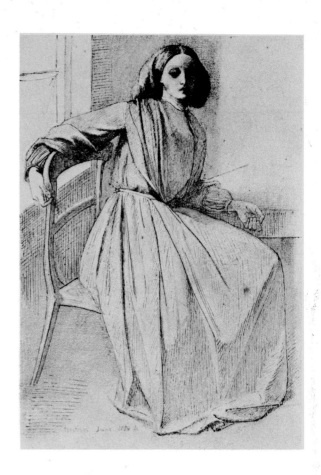

Elizabeth Siddal. Pencil, pen and ink, $9\frac{3}{16}'' \times 7''$, 1854.
(*The Fitzwilliam Museum, Cambridge*)

meet anyone new and remained alone in his house, painting steadily. In 1864 he completed *Beata Beatrix*, his memorial to his wife. Frederic George Stephens, a member of the original Brotherhood, and now art critic for *The Athenaeum*, wrote glowing reviews of his work. But Rossetti refused to exhibit, his fear of public criticism now deeper than ever. He was to write to C. H. Hallé in 1877, in explanation of his refusal to show his work at the Grosvenor, "What holds me back is simply that lifelong feeling of dissatisfaction which I have experienced from the disparity of aim and attainment in what I have all my life produced as best I could. My wish to assure you that distrust of myself and not others is the cause of my little important reticence."

Rossetti detested the French Impressionism that invaded London in 1866. Yet in a sense his own work served as a bridge between the new purely formal style and the old anecdotal and literary one. Design concerned him more than accuracy of detail and his style served the expression of his personality. He was able to earn £3000 in 1867 but was, as ever, in debt. His health was declining and he suffered from chronic insomnia. He drank in order to sleep and often did not go out except during the long nights, when he took to wandering alone along the river. His sight began to fail, and fearing he would go blind he panicked, drank even more and sank into deep depression. His doctors advised him that his condition was nervous, that his eyes would recover if he stopped working and rested. Forbidden to paint he took various trips into the country, hoping to relax, and once again turned seriously to poetry. His renewed poetic activity in 1868 coincided with the deepening of his relationship with Jane Morris, and for a time his health and spirits revived remarkably. Jane and William Morris had a mutually cool marriage, Rossetti adored her and Morris tacitly agreed to the affair. Like Elizabeth Siddal, Jane Morris is a mysterious and vague figure, the only real record of her being the endless portraits Rossetti did of her and the photographs he posed her for. Her unique beauty became, under Rossetti's hand, the Pre-Raphaelite ideal. His wish to "make the symbolism inherent in the fact" was perhaps most completely achieved with Jane Morris, as Henry James observed: "*Je n'en reviens pas* – she haunts me still. A figure cut out of a missal – out of one of Rossetti's or Hunt's pictures – to say this gives but a faint idea of her, because when such an image puts on flesh and blood, it is an apparition of fearful and wonderful intensity. It's hard to say whether she's a grand synthesis of all the Pre-Raphaelite pictures ever made – or they are a 'keen analysis' of her – whether she's an original or a copy. In either case she is a wonder. Imagine a tall lean woman in a long dress of some dead purple stuff, guiltless of hoops (or of anything else I should say), with a mass of crisp black hair, heaped into great wavy projections on each of her temples, a thin pale face, great thick black oblique brows, joined in the middle and tucking themselves away under her hair, a mouth like the 'Oriana' in our illustrated Tennyson,

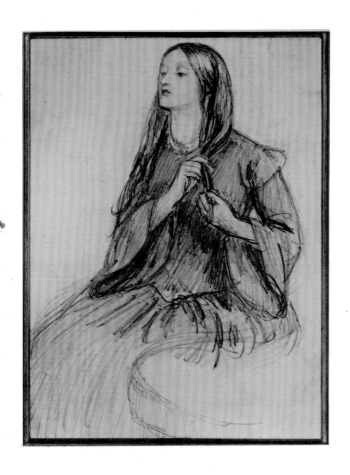

Elizabeth Siddal. Pencil, $6\frac{3}{4}'' \times 5''$.
(*The Tate Gallery, London*)

a long neck, without any collar, and in lieu thereof some dozen strings of outlandish beads. In fine complete."

Inspired by his ultimately hopeless love for Jane Morris, Rossetti wrote his sonnet sequence *The House of Life*, the introspective poems that were to have a major influence on the English Aesthetic writers. In 1869 encouraged by his friends to publish, he decided to have his manuscript removed from his wife's grave, an act that intensified his guilt over her death and in an effort to gain relief from his insomnia and its multiple consequences he began to take a new and powerful drug, chloral hydrate, and was soon addicted. In *D. G. Rossetti as Designer and Writer* his brother described the deadlock of cause and effect that characterized his condition: "Constant insomnia (beginning towards 1867), and its counter-action by reckless drugging with chloral, co-operated, no doubt, to the same disastrous end; indeed, I find it impossible to say whether the more potent factors in the case were insomnia and chloral, which gave morbid virulence to outraged feelings, or outraged feelings which promoted the persistence of insomnia, and the consequent abuse of chloral. All three had their share in making my brother a changed man from 1872 onwards."

In 1871, with the publication of *Poems by D. G. Rossetti* he found himself acclaimed as the chief poet-painter of his day. This exalted status did much to improve his spirits, and that same year he and Morris took Kelmscott Manor under joint tenancy. The weeks Rossetti spent there with Jane Morris and her children were some of the happiest of his life but, despite the temporary relief he found at Kelmscott, his condition was steadily deteriorating. He was already showing signs of paranoia and took the unnecessary precaution of arranging for his friends to review his book in the major literary journals. He was convinced that an "enemy" was waiting to attack and in October 1871 the enemy appeared, in the form of a vicious article published in the *Contemporary Review* under the pseudonym of "Thomas Maitland". The real author of "The Fleshly School of Poetry" was Robert Buchanan, a frustrated and jealous writer, who carefully aimed his accusations at the most deeply-rooted moral prejudice of his time. Sensuality, nudity or any overt sexual reference in art was anathema in English society and Rossetti was aware that if his poetry was condemned on this ground he would be ruined financially and his reputation destroyed. The use of a pseudonym seemed to Rossetti to be proof that this was part of a larger conspiracy, a plot against him that he was bound to expose. Ultimately "The Fleshly School of Poetry" only slightly reduced Rossetti's standing, but it left him permanently suspicious. His friends advised him to control his originally violent retort and when "The Stealthy School of Criticism" was finally published in the Athenaeum in December 1871 it was much revised and like his letters from that period, did not reflect his state of mind.

In the summer of 1872 he broke down completely and attempted suicide by taking laudanum. Once again he was able to recuper-

ate at Kelmscott with Jane Morris but by 1874 he was broken and despairing. Although Mrs. Morris continued to sit for him, his partnership in The Firm was terminated and his old friends, from whom he had been turning away gradually for years, nearly all disappeared from his life. Taking up to 180 grains of chloral a day he was forced to carry out elaborate schemes to obtain the drug from chemists when his physician tried to curb his dosage. He took pains to shield his addiction from his patrons and the public but he was concerned with the effect of the drug on his powers of inspiration and his intellectual capabilities. In October 1877 he wrote to Frederick James Shields, "As to the eternal drug, my dear Shields, if I suffer at times from morbidity, it is also possible for others to take a morbid view of the question. I am quite certain that I have, as an artist should, made solid progress in the merit of my work, such as it is, and this chiefly within the last five years, during which I have supplied by application some serious qualities which had always been deficient in my practice, and produced, I will venture to say, at least a dozen works (among those covering the time) which are unquestionably the best I ever did. In those only which *need* deep tone, will it be found. Some are among the brightest I ever produced – as *La Bella Mano*, *The Sea-Spell* . . . The only picture indeed which at all really tends to darkness is the *Astarte* and I remember that on the only occasion when you saw this by day-light, you quite exclaimed as to its brightness and fullness of colour when properly seen. To reduce the drug as far as possibility admits is most desirable . . . but if an opinion were to get abroad that my works were subject to a derogatory influence which reduced their beauty and value, it would be most injuring to me, and would in reality be founded on foregone conclusion as to the necessary results of such a medicine, and not on anything really provable from the work itself."

His last book, *Ballads and Sonnets*, published in 1881, was comparatively unsuccessful, probably as a result of Buchanan's attack. He was cared for now by Ford Madox Brown, Fanny Cornforth and his family and, although his paintings continued to fetch high prices, he was still heavily in debt and his household in chaos. Early in 1882, accompanied by his latest disciple, Hall Caine, he went to Birchington-on-Sea and died there on April 9th, Easter Day of that year.

As the most influential painter and poet of the Pre-Raphaelites, Rossetti gave to the movement what we now assume to be its most distinctive characteristics. The rich colour and detail, the mediaeval, Dantesque and mythical themes, the portraits of many women who seem to have but one face – these all are the distinguishing elements of Rossetti's work. The realistic, moral painters Holman Hunt, Ford Madox Brown, Millais and the others associated with the original Pre-Raphaelite Brotherhood were inspired by different concerns. Literary where Rossetti was poetic, moral and realistic where he was romantic, masters of technique where he was unskilled and impatient, they were, however, united with him in their rebellion against the dead art of a materialistic era. Rossetti's art was not a transformation of an external but of his own internal reality. The reality of his soul was his domain as an artist, his goal was to faithfully portray what was to him: "The soul's sphere of infinite images."

Rossetti was capturing the Victorian imagination with *The Sea-Spell* and *Proserpine* at the same time that Cézanne, poor and unknown, was discovering the structural principles which came to revolutionize twentieth century art. With the emergence of Cubism in painting and Imagism in poetry the detailed naturalism of the Pre-Raphaelites appeared artificial and overblown. Yet in the Rossetti centenary year, 1928, certain critics of the new art, like Roger Fry, found foreshadowings of the modern style in Rossetti's emphasis on design and colour. We are now, it seems, once again drawn to the intensely human and passionate quality of his art, the quality which in his own lifetime gave, as Evelyn Waugh put it, "melodious expression to the regrets and aspirations of baffled humanity". In this book the critical comment shall be left to the critics, both enthusiastic contemporaries and the more objective later ones who, despite their justified reservations, could not wholly resist the fascination of Rossetti's powerful and poetic world.

SUSAN MILLER

Genevieve. Pen and ink, 10¾" × 5½", 1848. (*The Fitzwilliam Museum, Cambridge*)

This drawing was designed for The Cyclographic Society and illustrates Coleridge's poem *Love*, in which the heroine is called Genevieve.

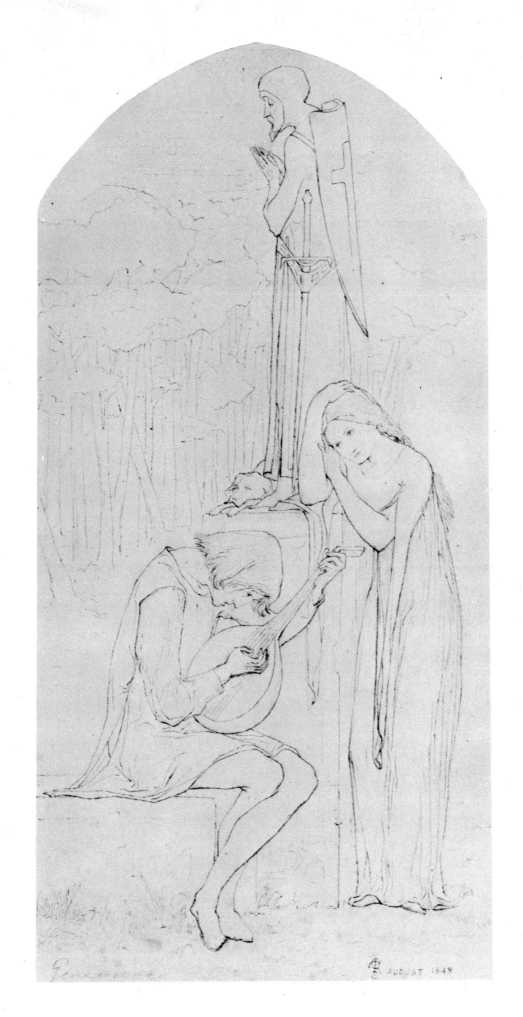

MARY'S GIRLHOOD

(For a Picture)

I

This is that blessed Mary, pre-elect
 God's virgin. Gone is a great while, and she
 Dwelt young in Nazareth of Galilee.
Unto God's will she brought devout respect,
Profound simplicity of intellect,
 And supreme patience. From her mother's knee
 Faithful and honest; wise in charity;
Strong in grave peace; in pity circumspect.

So held she through her girlhood; as it were
 An angel-watered lily, that near God
 Grows and is quiet. Till, one dawn at home,
She woke in her white bed, and had no fear
 At all,—yet wept till sunshine, and felt awed:
 Because the fulness of the time was come.

II

These are the symbols. On that cloth of red
I' the centre is the Tripoint: perfect each,
Except the second of its points, to teach
That Christ is not yet born. The books—whose head
Is golden Charity, as Paul hath said—
Those virtues are wherein the soul is rich:
Therefore on them the lily standeth, which
Is Innocence, being interpreted.

The seven-thorn'd briar and the palm seven-leaved
Are her great sorrow and her great reward.
Until the end be full, the Holy One
Abides without. She soon shall have achieved
Her perfect purity: yea, God the Lord
Shall soon vouchsafe His Son to be her Son.

1870

The Girlhood of Mary Virgin. Oil, 32¾" × 25¾", 1849. (*The Tate Gallery, London*)

The Girlhood of Mary Virgin, Rossetti's first painting, was completed when he was twenty years old. It was shown at the Free Exhibition in 1849 and was the first painting exhibited in public to bear the initials "P.R.B." although it was done more in the non-naturalistic, "Early Christian" style of the German Pre-Raphaelites than according to the doctrine of the English Brotherhood. It was begun in 1848 at the Cleveland Street studio that Rossetti shared with Holman Hunt and executed under the guidance of Hunt and Ford Madox Brown Rossetti's mother, Mrs. Gabriele Rossetti, modelled for St. Anne, his sister Christina for Mary and a servant of the Rossetti family for St. Joachim. Rossetti grew impatient with the many technical difficulties he encountered and eliminated the second angel, referred to in the letter which follows, because of problems with the child model. In November, 1848 Rossetti wrote to his godfather Charles Lyell about the picture, which was then a few months underway: "The warm interest which you have always been so kind as to take in my studies emboldens me to believe that you may not feel altogether indifferent as to the success of the picture which I am preparing for next year's Exhibition; and which I will therefore describe. It belongs to the religious class which has always appeared to me the most adapted and the most worthy to interest the members of a Christian community. The subject is the education of the Blessed Virgin, one which has been treated at various times by Murillo and other painters – but, as I cannot but think, in a very inadequate manner, since they have invariably represented her as reading from a book under the superintendence of her Mother, St. Anne, an occupation obviously incompatible with these times, and which could only pass muster if treated in a purely symbolical manner. In order, therefore, to attempt something more probable and at the same time less commonplace, I have represented the future Mother of Our Lord as occupied in embroidering a lily – always under the direction of St. Anne; the flower she is copying being held by two little angels. At a large window (or rather aperture) in the background, her father, St. Joachim, is seen pruning a vine. There are various symbolic accessories which it is needless to describe. I have made several studies in chalk for the picture, besides the design for the composition; but the only parts yet painted in on the canvas are the background . . . and a portion of the figure of the Blessed Virgin, for which Christina sits to me; her appearance being excellently adapted to my purpose." The sonnets were printed on gold paper and attached to the frame of the painting.

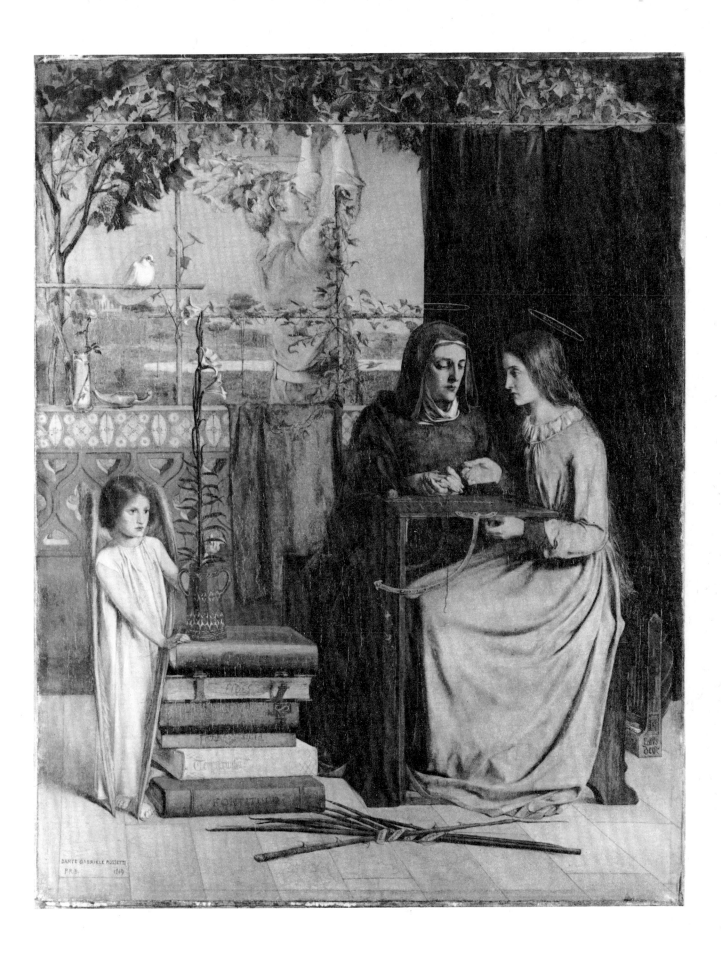

The Girlhood of Mary Virgin.

MARY MAGDALENE AT THE DOOR OF SIMON THE PHARISEE
(For a Drawing)

'Why wilt thou cast the roses from thine hair?
 Nay, be thou all a rose,—wreath, lips, and cheek.
 Nay, not this house,—that banquet-house we seek;
See how they kiss and enter; come thou there.
This delicate day of love we two will share
 Till at our ear love's whispering night shall speak.
 What, sweet one,—hold'st thou still the foolish freak?
Nay, when I kiss thy feet they'll leave the stair.'

'Oh loose me! See'st thou not my Bridegroom's face
 That draws me to Him? For His feet my kiss,
 My hair, my tears He craves to-day:—and oh!
What words can tell what other day and place
 Shall see me clasp those blood-stained feet of His?
 He needs me, calls, loves me: let me go!'

<div align="right">1870</div>

From The Athenaeum, *August* 14, 1875.

The fact that some of the finest pictures of modern production, the works of Mr. Rossetti, one of the most powerful and original artists, do not come before the public in these days of exhibitions, and while claims for admiration are incessant, seems anomalous to many; and there are some who are disposed to resent the reticence of the artist either on himself or on his pictures, and they do this with all sorts of absurd expressions. The public has become so accustomed to the practice of exhibiting works of art, that many forget there is no law to compel a painter to show what he does; and they do not consider that the custom of public display in these matters is a comparatively modern one. At all events, it is certain that a very considerable proportion of the finer art-products of each year are never seen by the world at large. It is but the other day that Alfred Stevens, one of our ablest artists, died, and few knew what he had executed. Still, he had a large public commission; some of his designs could be indicated, and had been exhibited.

With Mr. Rossetti the case is totally different; he has not exhibited any of the productions of an extraordinarily splendid maturity of genius, the results of assiduously cultivated technical powers,—pictures about which all who see them declare that however super-subtle may be the motives of some, however spiritual may be the inspiration of most of their designs, there can be no other opinion than that to place the works before the world would be to ensure transcendent success for the painter, and to procure applause of the highest kind from all men of culture. Certain it is, that the paintings we have now to describe would appear like a magnificent revelation of the existence of treasure of glorious art existing almost unknown amongst us, *i.e.,* unknown to the general mass of art-lovers of our time. We are afraid that students in the future will be strongly puzzled to account for the existence of these paintings at a period when so much ineffable trash passed current with no small measure of popular admiration. The preciousness of these examples is not alone in their design, or other more purely intellectual elements, but in the gorgeous, superlative *technique* which distinguishes them now, and would never have failed to distinguish them, not even in the most resplendent days of Venetian painting. With Venetian painting the works of Mr. Rossetti most happily assort; but they are anything but reflexions of the pictorial glories of the city of the Bellinis and Titian. Our contemporary's works resemble these triumphs of Venice in some peculiar qualities—qualities which are properly Venetian, as splendour of colour, depth of tone, and combinations of colour and tone, with potent light and shade, so as, with the force of enchantment, to form in each instance a whole which is as original as it is magnificent. But, after all, it is sumptuous Venice, so to say, with a modern reading of the charm, with an infusion of modern thought, and as different as possible from that which yet lives on ancient canvases and panels.

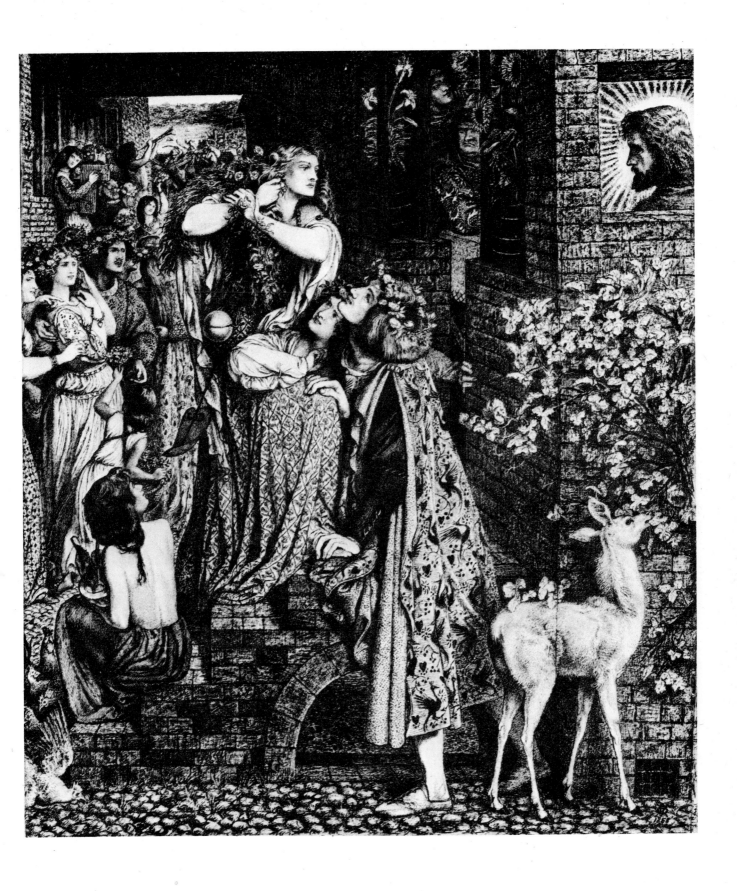

Mary Magdalene at the Door of Simon the Pharisee. Pen and India ink, 21¼″ × 18⅜″, 1858.
(*The Fitzwilliam Museum, Cambridge*)

Rossetti worked on this drawing from 1853 until 1859, and Ruskin thought the design so fine that he wished to trade *St. Catherine* for it. Burne-Jones sat for Christ and the actress Ruth Herbert for Mary.

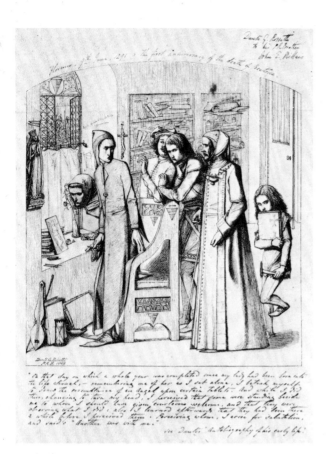

The First Anniversary of the Death of Beatrice.
Pen and ink, 15¾″ × 12⅞″, 1849. (*Birmingham City Museum and Art Gallery*)

Rossetti inscribed this passage from the *Vita Nuova* on the lower portion of the page: "On that day on which a whole year was completed since my lady had been born into the life church – remembering me of her as I sat alone, I betook myself to draw the resemblance of an Angel upon certain tablets. And while I did thus, chancing to turn my head, I perceived that some were standing beside me to whom I should have given courteous welcome, and that they were observing what I did: also I learned afterwards that they had been there a while before I perceived them. Perceiving whom, I arose for salutation and said: 'Another was with me'."

The First Anniversary of the Death of Beatrice.
Water-colour, 16½″ × 24″, 1853. (*Ashmolean Museum, Oxford*)

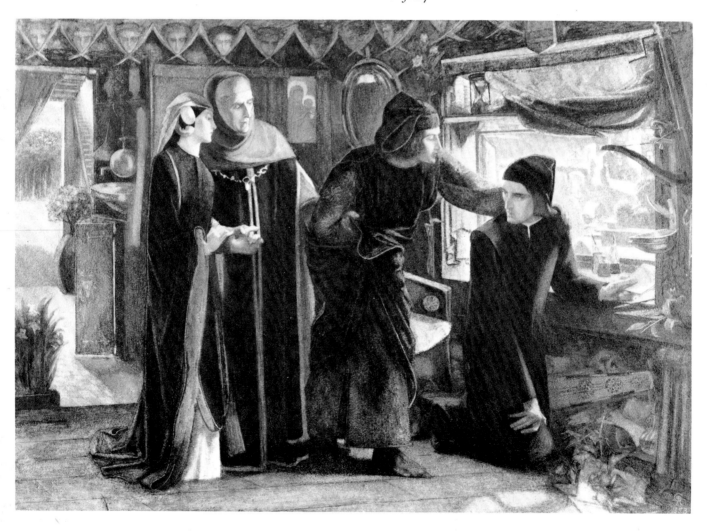

Study for **Giotto Painting the Portrait of Dante.** Pen and ink, 7″ × 8″, 1852. (*The Tate Gallery, London*)

The Raven. Pencil, pen with brown and black ink, and ink wash, 8¾″ × 6⅞″, c. 1847. (*Birmingham City Museum and Art Gallery*)

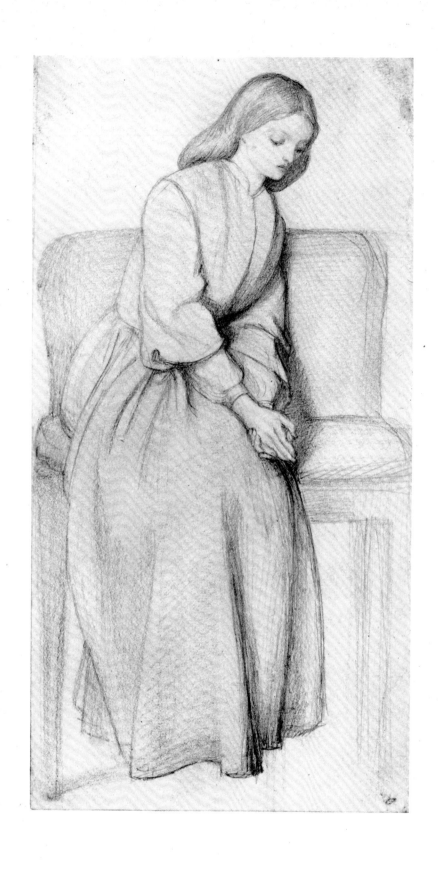

Study for **Dante's Vision of Rachel and Leah.** Pencil, 13⅝″×6¾″,
1855. (*Birmingham City Museum and Art Gallery*)

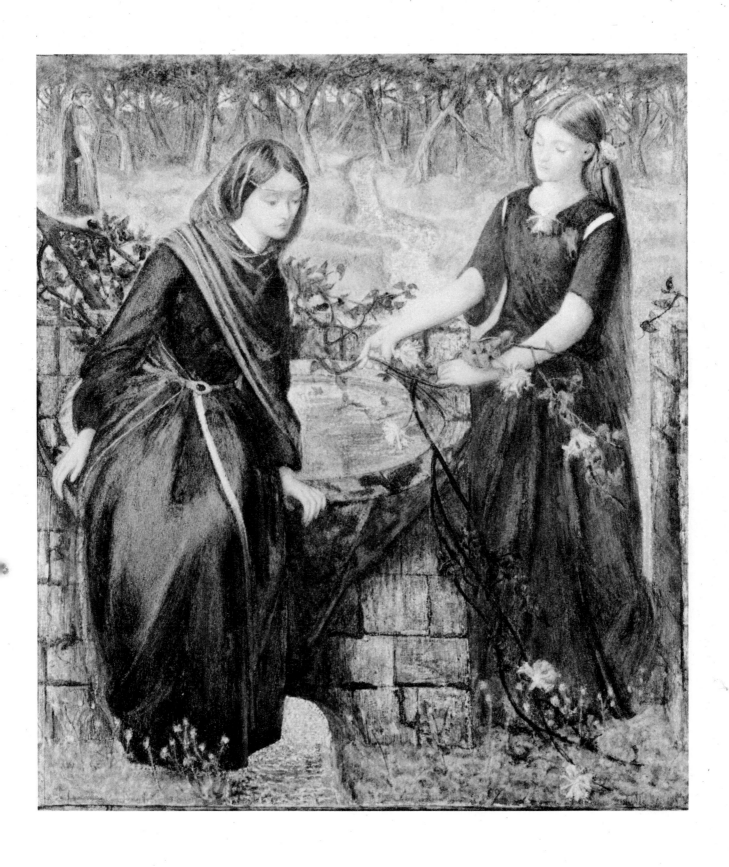

Dante's Vision of Rachel and Leah. Water-colour, 14″ × 12½″, 1855. (*The Tate Gallery, London*)

Illustrating Canto XXVII 97–108 of *Purgatorio,* this painting was the only one attempted of a series of four subjects from *Purgatorio* suggested by Ruskin. Ruskin paid Rossetti an extra £10 for it, bringing the price to an unexpected £30, although he found it "gloomy" despite the flowers and sunlight. Elizabeth Siddal sat for Rachel.

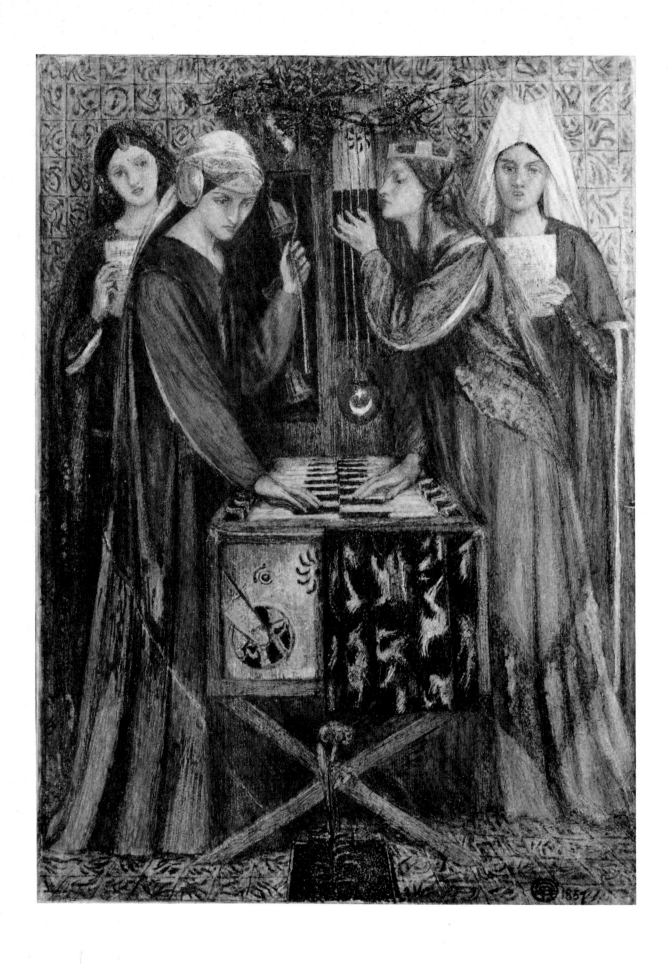

The Blue Closet. Water-colour, 13½″ × 9¾″, 1857. (*The Tate Gallery, London*)

This painting was bought by William Morris and inspired his poem of the same name in *The Defence of Guenevere*.

26

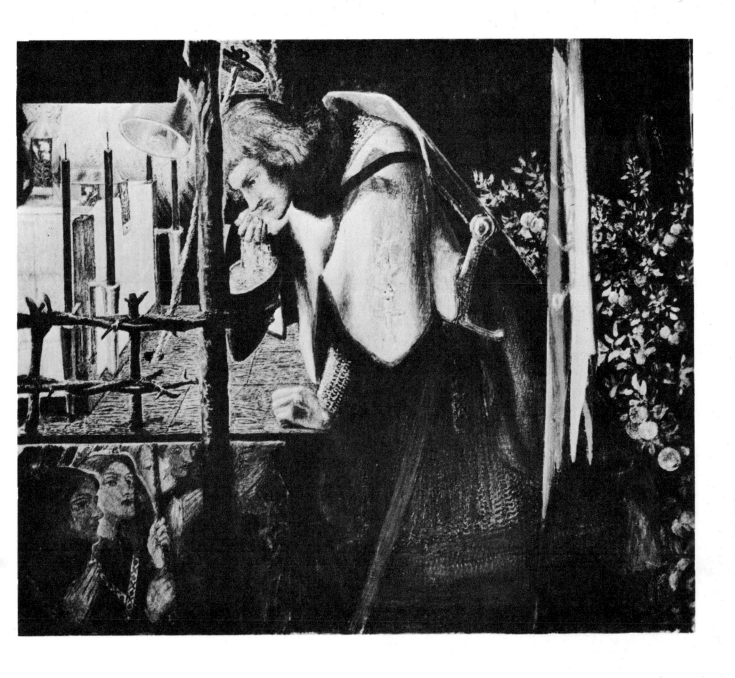

Sir Galahad at the Ruined Chapel. Water-colour, 11½″ × 13½″, 1859. (*Birmingham City Museum and Art Gallery*)

A water-colour version of a drawing for Moxon's *Tennyson,* to illustrate the following lines:

> ". Between the dark stems the forest glows,
> I hear a noise of hymns:
> Then by some secret shrine I ride;
> I hear a voice but none are there;
> The stalls are void, the doors are wide,
> The tapers burning fair.
> Fair gleams the snowy altar-cloth,
> The silver vessels sparkle clean,
> The shrill bell rings, the censer swings,
> And solemn chaunts resound between."

ROSSETTI'S WATER COLOURS OF 1857

To those who, like myself, think that the 20th century has brought about a renascence of the art of expressive design – a liberation of this element in painting from all kinds of interfering accessories – the case of Rossetti is of peculiar interest. For Rossetti more than any other English artist since Blake may be hailed as a forerunner of the new ideas. And yet one can imagine how bitterly, how violently he himself would have resented our conceptions of purity.

His case, then, puts the eternal question of content and form with a certain piquancy, and it is that I propose to discuss, taking as examples some of the early water colours now so fortunately acquired for the Tate Gallery. Rossetti was distinctively an inspired artist. He was something of an amateur, and could only paint at all under the stress of some special imaginative compulsion. The ordinary world of vision scarcely supplied any inspiration to him It was only through the evocation in his own mind of a special world, a world of pure romance, that the aspects of objects began to assume aesthetic meaning. Passionate desire was the central point of this world, but passion in itself was not enough; it must rage in a curiosity shop, amid objects which had for him peculiarly exciting associations.

Now, from my point of view the inspiration of the artist is really his own affair. It is only a prying curiosity, like that which makes us ask what colours or what mediums an artist uses, which dictates these inquiries. In strict justice I believe the critic has only to consider the nature of the formal result. But Rossetti displays his inspiration so elaborately, and invites our sympathy so naïvely and persistently, that one cannot help beginning with this.

Now, what struck me most in the examples at the Tate was that Rossetti's form became clear, definite and truly expressive almost exactly in proportion as he was concerned with the accessories of his drama – that just when he was most occupied with the central core of his theme, with the passion, his form fell to pieces, he became a mere illustrator and not a very good one. Take, for instance, *The Chapel before the Lists*. It is clear that Rossetti wanted to express the dramatic situation, the leave-taking of the lovers before the dangers of the tournament, and that the drama gained for him intensely in value from the fact that his lovers were surrounded by all the objects of mediaeval chivalry. One can see with what delight he has dwelt on all the possible furniture of such a scene, with what love he has elaborated and embroidered every nook and corner. What is surprising is that this antiquarian curiosity inspires real design, so that the architecture of all these forms is really moving. The long parallelogram of the opening in the tent crossed by the pyramid of the two lovers is perfectly planned. No less surprising is the "science" with which he plays the directions of his straight lines – the sword, the side of the helmet, the candlesticks against the main forms. And in the view out on to the lists, how perfectly he has found the position for all the little figures and objects with which his fancy loved to play. And while he handles these objects his sense of contour, his discovery of values and colour relations are clear, decisive and vital. In the figures themselves all is changed. He starts, it is true, with a fine general idea of volume and direction, but within the main contour all goes to pieces: colour becomes muddy and indefinite, contours vague, and plasticity timid and hesitating, because, I suppose, he was oppressed with the desire for detailed descriptive realism. He tried to get expression not by form but by description and by associated ideas.

I take *The Chapel before the Lists* as my first example because I think it the finest and most original of all in its general design, and the one in which the dramatic expression not only fails, but tends to injure the harmony elsewhere established. The same holds, however, in *The Tune of the Seven Towers*. Here there are delightful inventions of design, the boldest and most surprising motives like that of the staff of the banner and the bell-rope which cut across the figures, or the unexpected repetitions of forms in the belfries. The figures are here less emphatic; they are, as usual, beautifully placed, but they annoy us by the over-emphasis on psychological expression.

In *The Wedding of S. George and the Princess Sabra* the literary inspiration itself is less ambitious, more purely fantastic and humorous, as of some modern Carpaccio, and here for once at least one of the heads, that of the princess, is not an actively disturbing element in the design. It is clearly a portrait of Miss Siddal, and one fancies Rossetti was content to leave it at that without trying to put such a terrible weight of psychological expressiveness into it. The *Lucrezia Borgia* seems to me in general a failure, though it is almost redeemed by the beautiful drawing of the towel and the delightful rightness of the form in the design.

I never sympathized with the impressionist attacks on literary painting. It seemed to me unimportant whether the inspiration for harmonious and expressive form came from the contemplation of the kaleidoscope of external vision or from "the soul's sphere of infinite images". And it would seem that Rossetti, starting from the images which legend stirred within him, came nearer than any artist of the time to that close-knit unity of design which distinguishes all pure art. Only as compared with the great primitives, whom at times he so nearly approaches, he fails to assimilate into the form all the material of his imagination. To the spectator of a work of art it should be indifferent whence the inspiration came to the artist. His satisfaction in the form should be so complete that he asks no questions about it. Our interest in Rossetti's inspiration is itself an admission that the form is imperfect, that the work remains partly, though every so charmingly, illustrative. The strange thing is that Rossetti, who got so far, should not have taken just the next step which would have given him complete freedom.

From The Burlington Magazine, *June,* 1916.

ROGER FRY

The Wedding of St. George and the Princess Sabra. Water-colour, 13½″ square, 1857. (*The Tate Gallery, London*)

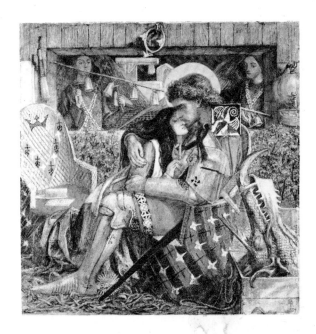

The Tune of Seven Towers. Water-colour, 12⅜″ × 17⅜″, 1857. (*The Tate Gallery, London*)

William Morris adopted this title for his poem in *The Defence of Guenevere.*

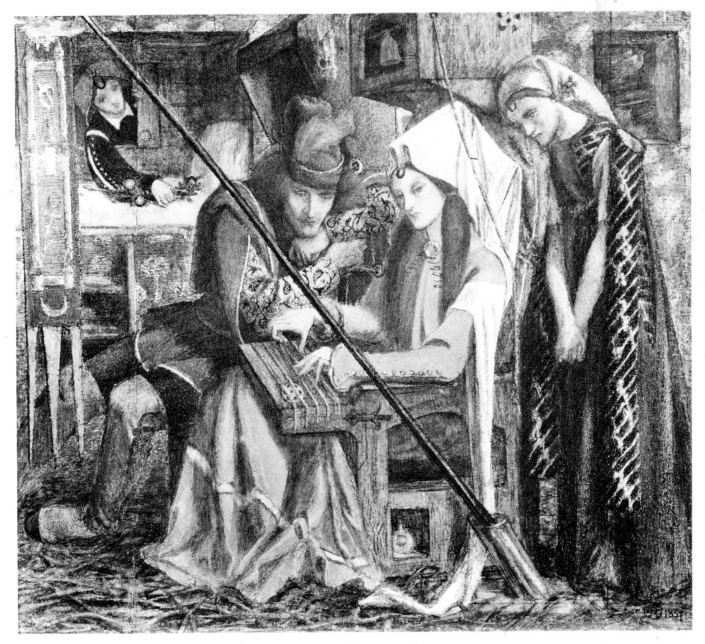

'Then saw I many broken hinted sights
 In the uncertain state I stepp'd into.
 Meseem'd to be I know not in what place,
Where ladies through the streets, like mournful lights,
 Ran with loose hair, and eyes that frighten'd you,
 By their own terror, and a pale amaze:
 The while, little by little as I thought,
The sun ceased, and the stars began to gather,
 And each wept at the other;
And birds dropp'd in mid-flight out of the sky;
And earth shook suddenly;
 And I was 'ware of one, hoarse and tired out,
Who ask'd of me: "Hast thou not heard it said.
Thy lady, she that was so fair, is dead".

'Then lifting up mine eyes, as the tears came,
 I saw the Angels, like a rain of manna,
 In a long flight flying back Heavenward;
Having a little cloud in front of them,
 After the which they went and said, "Hosanna";
 And if they had said more, you should have heard.
 Then Love said, "Now shall all things be made clear:
Come and behold our lady where she lies".
These 'wildering phantasies
Then carried me to see my lady dead.
Even as I there was led,
 Her ladies with a veil were covering her;
And with her was such very humbleness
That she appeared to say, "I am at peace".

'And I became so humble in my grief,
 Seeing in her such deep humility,
 That I said: "Death, I hold thee passing good
Henceforth, and a most gentle sweet relief,
 Since my dear love has chosen to dwell with thee:
 Pity, not hate, is thine, well understood.
 Lo! I do so desire to see thy face
That I am like as one who nears the tomb;
My soul entreats thee, Come".
Then I departed, having made my moan;
And when I was alone
 I said, and cast my eyes to the High Place:
"Blessed is he, fair soul, who meets thy glance!"
. . . Just then you woke me, of your complaisaunce".

From Dante's *Vita Nuova* translated by D. G. Rossetti, 1861

Dante's Dream at the Time of the Death of Beatrice. Water-colour, 18½″ × 25¾″, 1865. (*The Tate Gallery, London*)

In the original water-colour, illustrating Dante's vision of the death of Beatrice from the *Vita Nuova,* James Hannay's wife modelled for Beatrice and Annie Miller for one of the attendants. In 1863 Rossetti decided to repaint the picture, and, borrowing the water-colour from its owner, repeated the same design in oils with elaboration of detail. The new Beatrice was Mrs. Morris, with her hair painted golden. Alexa Wilding modelled for the attendant on the left. The attendant on the right was Maria Spartali, daughter of the Greek Consul General in London and married to Rossetti's friend William James Stillman, an American artist and journalist. Graham Robertson called Maria Spartali a "Mrs. Morris for Beginners. The two marvels had many points in common. . . . Yet Mrs. Stillman's loveliness conformed to the standard of ancient Greece and could be at once appreciated, while study of her trained the eye to understand the more esoteric beauty of Mrs. Morris and 'Trace in Venus' eye the gaze of Proserpine'", quoting from Rossetti's sonnet *Pandora.* Johnston Forbes-Robertson was the figure of Love, Dante either W. J. Stillman or Charles Augustus Howell.

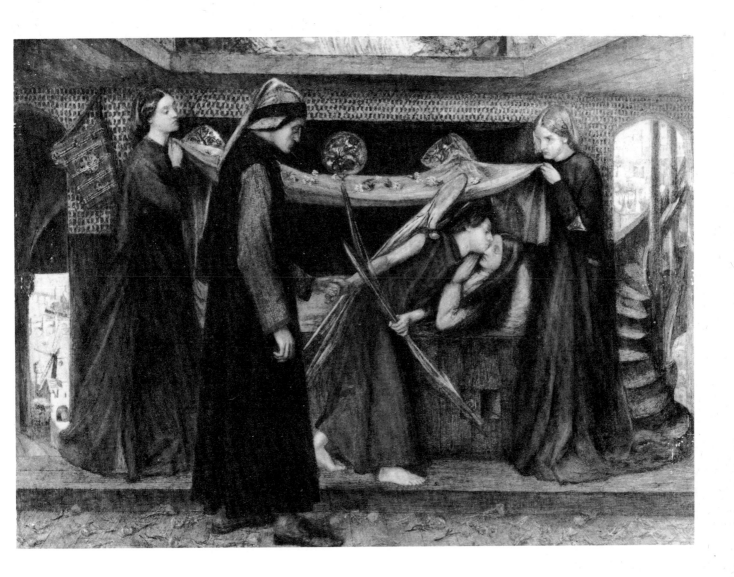

Dante's Dream at the Time of the Death of Beatrice.

Dante's Dream was the largest oil painting Rossetti ever did and its successful completion was extremely important to him. As usual he both needed technical advice and feared criticism. In August, 1870, troubled by the size of the figures, he sought the help of Ford Madox Brown, telling him "My soul is vexed with the following point:–The women in my picture being 62 inches high, will it do for the man to be 65 inches, or should he be taller? I've got him traced on the canvas, and fancy he looks all right, but am rather nervous about beginning to paint him, lest he should possibly need heightening. The women's faces are 5½ inches long. Do you think half an inch more is enough for his face – i.e. six inches? Proportions always bother me more than anything else." To Alice Boyd, in November, 1870, he expressed his susceptibility to conflicting criticism and his practice, as regards this painting, of protecting himself from it, "I have not shown it to anyone as yet, and so it has all the more hold on me. No one has had the chance of breaking to me delicately as a painful necessity all the needs I most meant to supply in it, or of smiling when I tell them so and still saying with an incredulous air: 'Ah, yes, that must be done'. However, I'm quite willing to admit that a picture often gains by being shown in progress, only one loves it so much better as long as one keeps it to oneself, and is so much likelier to get straight on with it than when A. has patronized it, B. stood silent before it, and C. fancied you must have got so much further forward." Yet in the end he was satisfied with the painting, as he wrote to the painter Frederick Sandys in 1873, "Just lately, since I painted that large picture, I feel for the first time in my life something like a sense of *style* in my work, a quality quite deficient before with me . . . The fact is, to paint even one big picture is one's best chance of improvement – but then the picture itself must hang on a staircase at best, to say nothing of the loss it is to one to paint it."

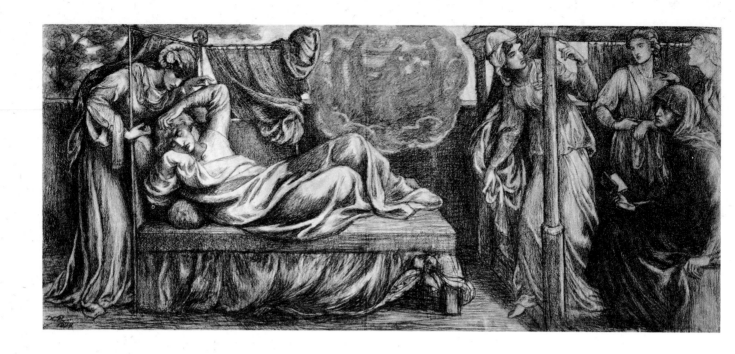

Study for **Dante's Dream. Predella Number One, Dante Dreaming.** Black crayon, 17⅜″ × 39¾″, 1879. (*The Fogg Museum of Art, Harvard University*)

St. Catherine. Oil, 13½″ × 9½″, 1857. (*The Tate Gallery, London*)

Dante's Dream at the Time of the Death of Beatrice. Oil, 83″ × 125″, 1871. (*Walker Art Gallery, Liverpool*)

Ecce Ancilla Domini! Oil, 25⅝″ × 16½″, 1850. (*The Tate Gallery, London*)

The negative critical response this painting received when exhibited in 1850 at the Portland Gallery discouraged Rossetti from showing any more of his work in public, a reluctance that remained with him for the rest of his life. On the basis of this painting and *The Girlhood of Mary Virgin, The Athenaeum* declared that "In point of view of religious sentiment Mr. Rossetti stands the chief of this little band" (the Pre-Raphaelite Brotherhood). A year or so later he changed the title of the painting to *The Annunciation* to avoid the accusations of "popery" that the use of the Latin seemed to arouse. The subject illustrates the last lines of Rossetti's sonnet *Mary's Girlhood* written to accompany his painting *The Girlhood of Mary Virgin:* "Till, one dawn at home,/She woke in her white bed, and had no fear/At all,–yet wept till sunshine, and felt awed:/Because the fulness of the time was come." Christina Rossetti sat for the Virgin. Although several people modelled for the Archangel the resemblance to William Michael Rossetti is the strongest. Exasperated by technical difficulties Rossetti was on the point of abandoning the painting several times and often referred to it in such terms as "the blessed white daub". In January, 1853 he wrote to Ford Madox Brown: "This Blessed afternoon the blessed white eye-sore will be finished Yesterday after giving up the Angel's head as a bad job (owing to William's malevolent expression) at about one o'clock I took to working it out of my own intelligence, and got it better by a great deal than it has yet been. I have put a gilt saucer behind his head, which crowns the *China*-ese character of the picture." When Rossetti saw the painting again in 1874 he wrote to Brown: "I have got the little *Annunciation* – alas! in some of the highest respects I have hardly done anything else so good. It is quaint enough, but really has inspiration, of the kind infectious to those born to feel it; but how many such are there?"

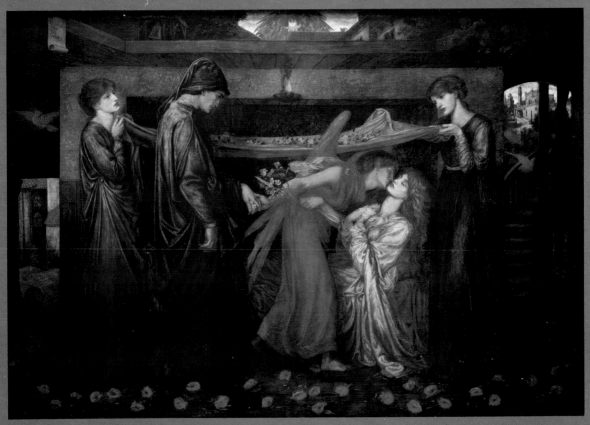

Dante's Dream at the Time of the Death of Beatrice. 1871. (Walker Art Gallery)

◀ Ecce Ancilla Domini! 1850. (The Tate Gallery)

▼ St. Catherine. 1857. (The Tate Gallery)

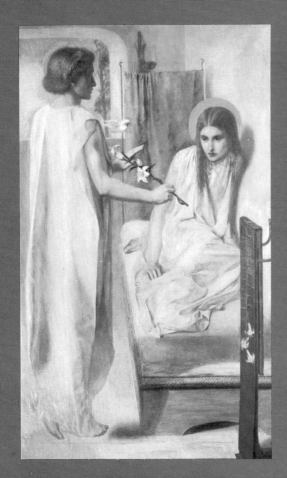

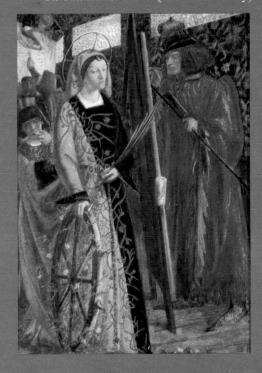

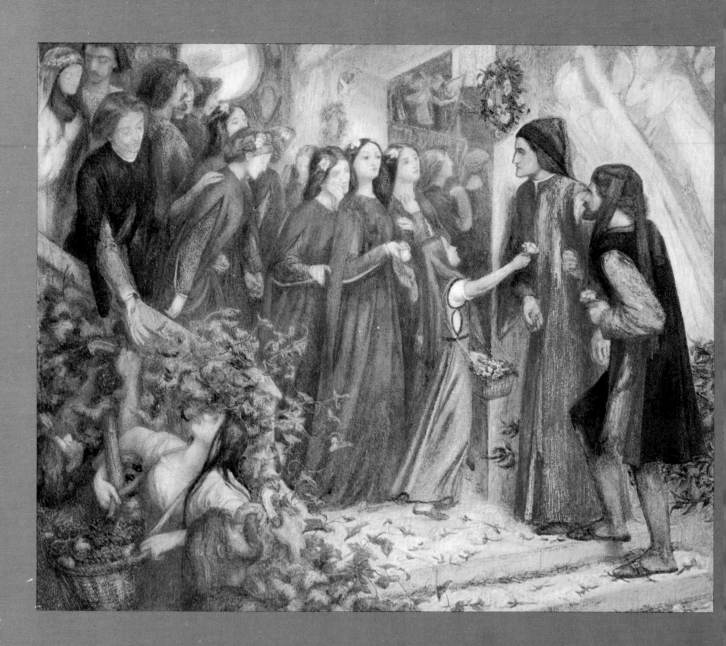

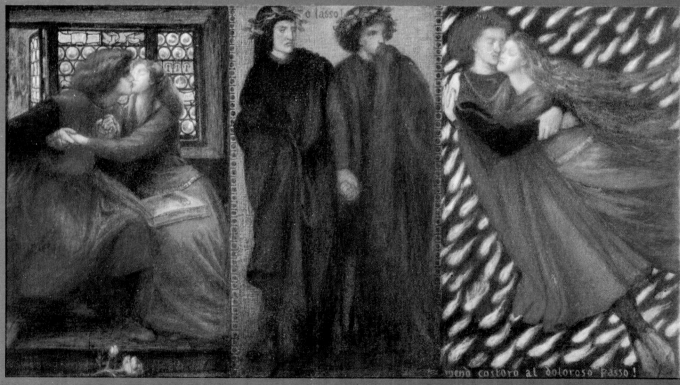

Study for **Ecce Ancilla Domini!** Pencil, 6⅝″ × 3¾″, 1849. (*Birmingham City Museum and Art Gallery*)

Study for **Ecce Ancilla Domini!** Pencil, 7¾″ × 5⅝″, 1849. (*The Tate Gallery, London*)

Top left **Beatrice, Meeting Dante at a Marriage Feast, Denies Him Her Salutation.** Water-colour, 13¾″ × 16¾″, 1851. (*Birmingham City Museum and Art Gallery*)

This painting, exhibited at the Winter Exhibition of water-colours at Pall Mall in 1852, was the first of Rossetti's pictures that Ruskin had seen. Ruskin soon arranged to come to Rossetti's Chatham Place studio to view his work and, convinced of his talents as a painter, began to champion him, making a name for the previously unknown artist. That Rossetti was both flattered by and resentful of his need for Ruskin's praise is evident in this passage from a letter to Thomas Woolner, written in April, 1853: "MC. sent me a passage from a letter of Ruskin's about my Dantesque sketches exhibited this year at the Winter Gallery ... R[uskin] goes into raptures about the colour and grouping which he says are superior to anything in modern art – which I believe is almost as absurd as certain absurd objections which he makes to them. However, as he is only half informed about art, anything he says in favour of one's work is of course sure to prove invaluable in a professional way, and I only hope, for the sale of my rubbish, that he may have the honesty to say publicly in his new book what he has said privately – but I doubt this. Oh! Woolner – if one could only find the 'supreme' Carlylian Ignoramus – him who knows positively the least about Art of any living creature – and get *him* to write a pamphlet about one – what a fortune one might make. It now seems that Ruskin had never seen any work of mine before, though he never thought it necessary to say this in writing about the PRB." Rossetti's relationship with Ruskin was to grow increasingly ambivalent and stormy. In 1856 he began to make a copy of *Beatrice Meeting Dante at a Marriage Feast* for Ruskin who, disliking the face of a bridesmaid, ordered Rossetti to alter it according to his wishes, to which Rossetti responded by painting out the entire head. Ruskin then seized another painting, *The Holy Passover*, fearing that Rossetti would "ruin" that as well. When the *Beatrice* was at last completed Ruskin no longer wanted the painting, telling Rossetti that he "was a conceited monkey, thinking your pictures right when I tell you positively they are wrong. What do you know about the matter, I should like to know?" Elizabeth Siddal modelled for Beatrice.

Bottom left **Paolo and Francesca da Rimini.** Water colour, 9¾″ × 17½″, 1855. (*The Tate Gallery, London*)

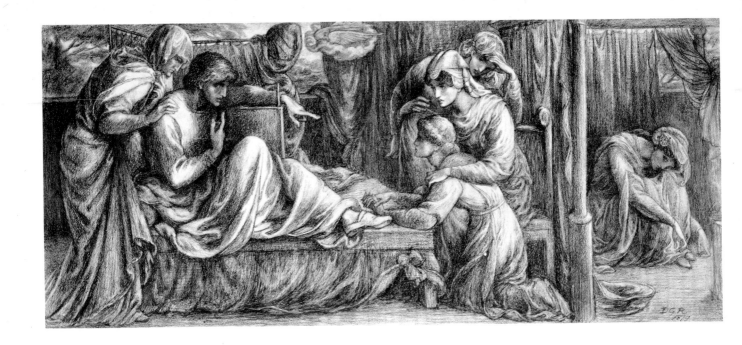

ON THE 'VITA NUOVA' OF DANTE

As he that loves oft looks on the dear form
　　And guesses how it grew to womanhood,
　　And gladly would have watched the beauties bud
And the mild fire of precious life wax warm:—
So I, long bound within the threefold charm
　　Of Dante's love sublimed to heavenly mood,
　　Had marvelled, touching his Beautitude,
How grew such presence from man's shameful swarm.

At length within this book I found pourtrayed
　　Newborn that Paradisal Love of his,
And simple like a child; with those clear aid
　　I understood. To such a child as this,
Christ, charging well his chosen ones, forbade
　　Offence: 'for lo! of such my kingdom is.'

1870

. . . it chanced on a day that my most gracious lady was with a gathering of ladies in a certain place; to the which I was conducted by a friend of mine; he thinking to do me a great pleasure by showing me the beauty of so many women . . . And they were assembled around a gentlewoman who was given in marriage on that day; the custom of the city being that these should bear her company when she sat down for the first time at table in the house of her husband. Therefore I, as was my friend's pleasure, resolved to stay with him and do honour to those ladies. But as soon as I had thus resolved, I began to feel a faintness and a throbbing at my left side, which soon took possession of my whole body. Whereupon I remember that I covertly leaned my back unto a painting that ran round the walls of that house; and being fearful lest my trembling should be discerned of them, I lifted mine eyes to look on these ladies, and then first perceived among them the excellent Beatrice. And when I perceived her, all my senses were overpowered by the great lordship that Love obtained, finding himself so near unto that most gracious being, until nothing but the spirits of sight remained to me; and even these remained driven out of their own instruments, because Love entered in that honoured place of theirs, that so he might the better behold her. And although I was other than at first, I grieved for the spirits so expelled, which kept up a sore lament, saying: 'If he had not in this wise thrust us forth, we also should behold the marvel of this lady'. By this, many of her friends, having discerned my confusion, began to wonder; and together with herself, kept whispering of me and mocking me. Whereupon my friend, who knew not what to conceive, took me by the hands, and drawing me forth from among them, required to know what ailed me. Then, having first held me at quiet for a space until my perceptions were come back to me, I made answer to my friend: 'Of a surety I have now set my feet on that point of life, beyond the which he must not pass who would return'. From Dante's *Vita Nuova* translated by D. G. Rossetti, 1861

Study for **Dante's Dream. Predella Number Two,
Dante Awakening.** Black and red crayon,
17¼″ × 39¾″, 1879. (*The Fogg Museum of Art, Harvard
University*)

Study for **Beatrice, Meeting Dante at a Marriage Feast, Denies
Him Her Salutation.** Pencil, 7⅛″ × 3⅛″, c. 1851. (*Birmingham City
Museum and Art Gallery*)

Dr. Johnson at the Mitre. Pen and ink, 8½″ × 8¼″, 1860. (*The Fitzwilliam Museum, Cambridge*)

An illustration of the following passage from Dr. Maxwell's *Collectanea* taken from Boswell's *Life of Dr. Johnson*: "Two young women from Staffordshire visited him when I was present to consult him on the subject of Methodism, to which they were inclined, 'Come', said he, 'You pretty fools, dine with Maxwell and me at the Mitre and we will talk over the subject', which they did and after dinner he took one of them on his knees, and fondled them for half-an-hour together."

How They Met Themselves. Pen and ink and brush, 10½″ × 8¼″, 1851–60. (*The Fitzwilliam Museum, Cambridge*)

Completed while Rossetti and Elizabeth Siddal were on honeymoon in Paris in 1860, it is a copy of an old design that had been lost or destroyed. The Doppelganger legend that it illustrates fascinated Rossetti, and he called it his "Bogie" drawing. Two lovers are meeting their doubles in the woods – a certain omen of death.

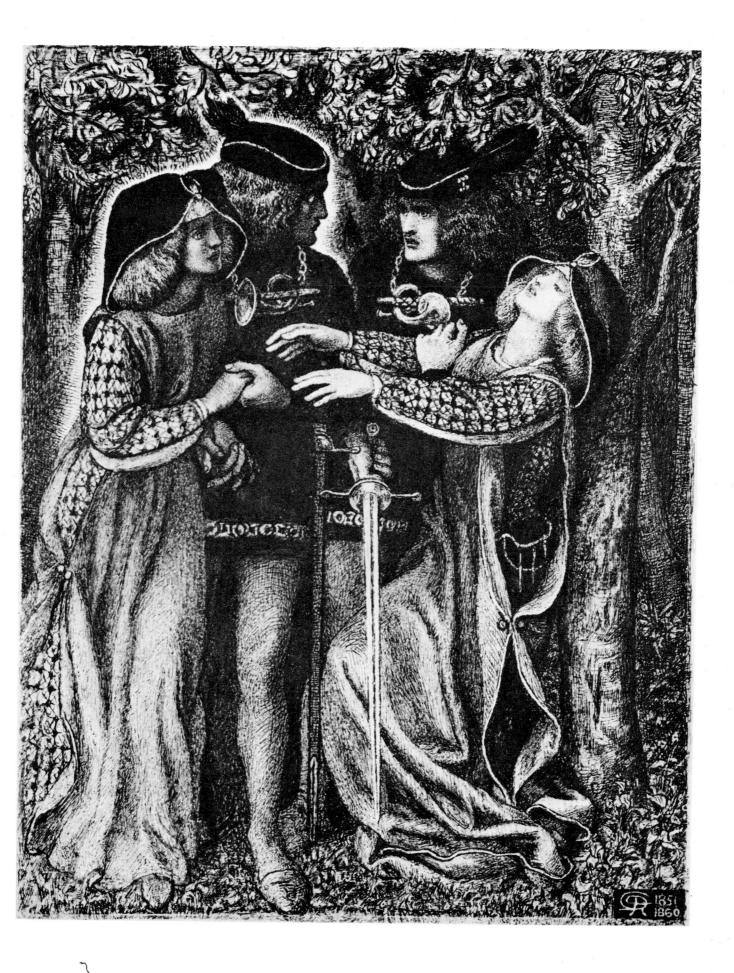

How They Met Themselves

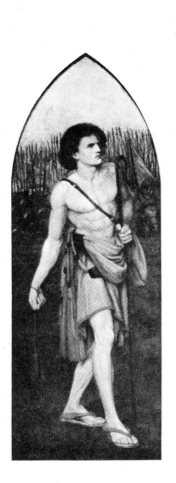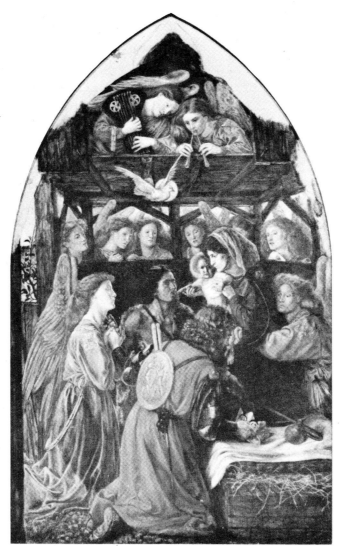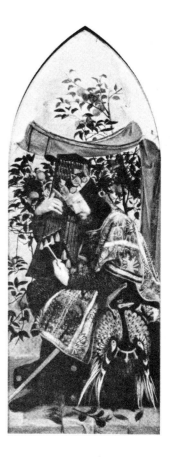

The Seed of David. Oil, centre 90″ × 60″, wings 73″ × 14½″, 1858–64. (*Llandaff Cathedral*)

Rossetti's £400 commission to paint a triptych at Llandaff Cathedral was obtained with the help of Ford Madox Brown and John Seddon the architect, who was working on the restoration of the Cathedral. Although Rossetti began the painting in 1858 it was not completed until 1864. The church authorities were exasperated by this long delay and by Rossetti's refusal to paint the light, decorative work they had wanted. But the painter's difficulties in finishing the painting were genuine. He suffered from a lack of knowledge of decorative art and finally admitted to Seddon that he had misjudged the effect and wished that the end of the cathedral could be painted black. Ruth Herbert was the first model for the Virgin, but the head of Mrs. Morris was eventually substituted. The head of King David was taken from William Morris, the Shepherd (possibly) from Burne-Jones and the child from Agnes Hughes, daughter of Arthur Hughes. According to Fanny Cornforth, David the shepherd was Timothy Hughes, the mechanic she married in 1860. In June, 1864 Rossetti described the triptych to his aunt Charlotte Lydia Polidori: " . . . The other day I finished and sent off to Llandaff the picture of *David as Shepherd*, completing the triptych which I have painted as the altarpiece of the Cathedral, and which altogether is entitled *The Seed of David*. It is intended to show Christ sprung from high and low in the person of David, who was both Shepherd and King, and worshipped by high and low – a King and a Shepherd – at his nativity. Accordingly in the centre-piece . . . an Angel is represented leading the Shepherd and King to worship in the stable at the feet of Christ, who is in his mother's arms. She holds his hand for the Shepherd and his foot for the King, to kiss – so showing the superiority of poverty over riches in the eyes of Christ; while the one lays his crook, the other his crown, at the Saviour's feet. There is an opening all round the stable, through which Angels are looking in, while other Angels are playing on musical instruments in a loft above. This is the centre-piece. The two side-pieces represent, on one side, David as Shepherd with the sling, walking forward and taking aim at Goliath, while the Israelite army watches the throw behind an entrenchment. The other side-piece is David as King playing on the harp. . . ."

From the review of Rossetti: His Life and Work *by Evelyn Waugh in* Spectator Literary Supplement, *May 12, 1928.*

"You must not say anything against Rossetti. Rossetti was a king," murmured Whistler whimsically in dying. "Why is he not an exiled king?" cried a young enthusiast. "But Gabriel was a genius," said the loyal Ford Madox Brown, who knew the best and worst of him, and who found it a weary business to go on painting without his approval. "In London, in the great days of a deep, smug, thick, rich, drab, industrial complacency, Rossetti shone for the men and women who knew him with the ambiguous light of a red torch somewhere in a dense fog" wrote the irrepressible Max Beerbohm, as he prepared to make some mirth out of the artist's esoteric circle, adding, "*On se moque de ce qu'on aime.*" Brilliant young men were the disciples of his prime; devoted friends conspired to mitigate the later agony of their sick sovereign. His early struggles over, this poet-painter of unique and vehement personality, masculine in his intellect, feminine in his sensibility, this cynical idealist of an Italian who never saw the Tuscan hills or the siren shore of Naples, lived like a retired Renaissance despot, with his courtiers, his jesters, his merchants, his suppliants, even with his menagerie. And indeed both Rossetti, and William Morris under his influence, in the versatility of their powers and the imaginative violence of their ways suggest a certain reversion to Renaissance psychology.

But some who did homage in their youth lived long enough to resent his dominance in the cold egoism of their age. And some have found that in the Vanity Fair of print it is easier to market the frailties than the victories of genius. And other survivors suffer from that dread of being out of date that so afflicts the old. Only the young dare to be out of date: thus, like the fervent Pre-Raphaelites themselves, they prepare their revolutions. But the twentieth-century young carry the natural disparagement of their immediate ancestors back through all the generations. They are busy making their new fire by rubbing cubist stones together. So, in this most centenarian year, the birthday of Gabriel Charles Dante Rossetti has few tributes, and these apologetic. Dante Gabriel Rossetti's genius is unpopular in this generation for many reasons. It is romantic, hybrid, difficult, aristocratic, and melancholy. The cruciform double-flower of his art is rooted in a consciousness of many cultures. He expresses a vision of life at once cloistered and sumptuous in a picture-making verse and a poetic painting so impressive that their rich interchanges can but awake mistrust in austere minds or temperaments. If he was three-quarters Italian, half of him belonged to the kingdom of Naples. The Tuscan strain of Dante was present in his brain as an intellectual shaping power; but the enchanted sensualism of Southern Italy was in his inheritance. He strove to baptize the pagan senses into the service of the spirit; but he knew too well what song the sirens sang; and he had just enough Northern blood to confuse the conflict with an extravagance of remorse of which the "average sensual man" would have been incapable. This dualism of the soul and body in love, the only sacrament, he held, by which men realize absolute beauty, the effort to reconcile them, the long lamenting regret over the failure, provide the themes of his poetic experience, limited, yet at once exquisite and magnificent. . . .

"It has all been said and written; they have hardly begun to paint it," said Rossetti, heretically as we suppose, insisting that "it," the imaginative substance, is identical for words and paint. He wrote out his doctrine early, in *Hand and Soul,* much the same as Leonardo's. We all know of his erratic apprenticeship, and his defects of drawing. But he could draw well enough to let desire, sorrow, beauty, mystery come through. It may be that those brilliant little mediaeval cloisons in pure bright water-colour, where sweet and sinister figures are prisoned in a missal-like architecture decorated with intense ingenuity, may yet prove most clearly his title to be a painter. The romantic fantasy of things like *The Wedding of St. George* and the *Blue Closet,* or *The Tune of Seven Towers,* is extraordinary; and, while the attack on the eyes disengages a violent faery delight in the true mediaeval way, it is also quite distinctly Rossetti's own original way. And even the later pictures, too steadily devoted to the Feminine Principle, when suddenly seen among the work of others, arrest unprejudiced eyes with the shock of their imaginative design before you can know what the subject is.

> "Look where Colour, the Soul's bridegroom, makes
> The House of Heaven splendid for the bride."

says Meredith. Rossetti certainly hung his tapestries too exclusively for the Bride, whether she was Lilith or Beatrice. He had his triumphs though; once when he painted *Monna Vanna,* soft and insolent in her great sleeves, like a Titian picture of a Venetian courtesan; once when he brought the Beloved unveiled before her radiant demilune of damsels; and once when he saw Jane Morris as his own goddess Persephone, lifting the fatal pomegranate. Loveliest of all, who will refuse to salute the pure ecstatic face of Beata Beatrix in her caves of rose and green?

I have said nothing of Rossetti as the enthusiast who wrought the Pre-Raphaelites into a Brotherhood, or as the inspirer of Morris and Burne-Jones. Of the influences on him of Keats, Shelley, Coleridge, Poe, and Blake, I have of necessity been silent. There is too much to say about his difficult art and his magnetic personality. Undoubtedly much more may be urged against both. But "the creative act is wild, unwilling, and painful," as a continental critic has well said; and when the centenary of a sincere artist comes round, it is better to be grateful. Whatever Rossetti's faults, the accent and gesture of greatness are present in his painting, his poetry, and himself. He may be truly "a king in exile" now. The singular and intricate beauty of his language will echo more clearly when we recover some of our lost vocabulary; and the cloud and flame of his matter will blind and burn again when Love comes back to his own.

RACHEL ANNAND TAYLOR

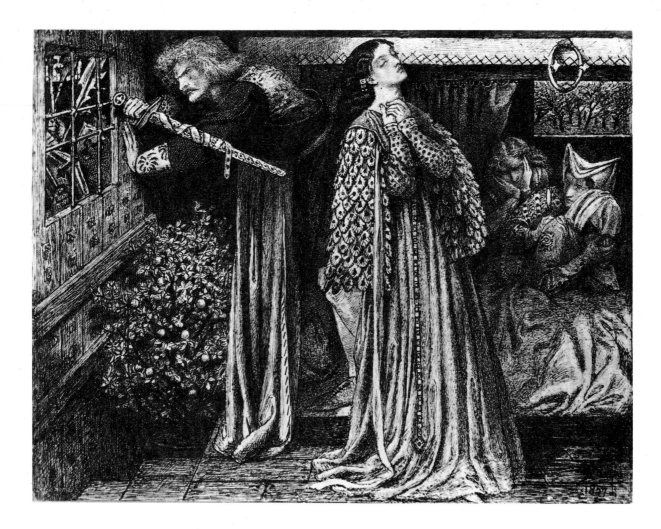

Sir Launcelot in the Queen's Chamber. Pen and black and brown ink, 10¼″ × 13¾″, 1857. (*Birmingham City Museum and Art Gallery*)

LOVE-LILY

Between the hands, between the brows,
 Between the lips of Love-Lily,
A spirit is born whose birth endows
 My blood with fire to burn through me;
Who breathes upon my gazing eyes,
 Who laughs and murmurs in mine ear,
At whose least touch my colour flies,
 And whom my life grows faint to hear.

Within the voice, within the heart,
 Within the mind of Love-Lily,
A spirit is born who lifts apart
 His tremulous wings and looks at me;
Who on my mouth his finger lays,
 And shows, while whispering lutes confer,
That Eden of Love's watered ways
 Whose winds and spirits worship her.

Brows, hands, and lips, heart, mind, and voice,
 Kisses and words of Love-Lily,—
Oh! bid me with your joy rejoice
 Till riotous longing rest in me!
Ah! let not hope be still distraught,
 But find in her its gracious goal,
Whose speech Truth knows not from her thought
 Nor Love her body from her soul.

1870

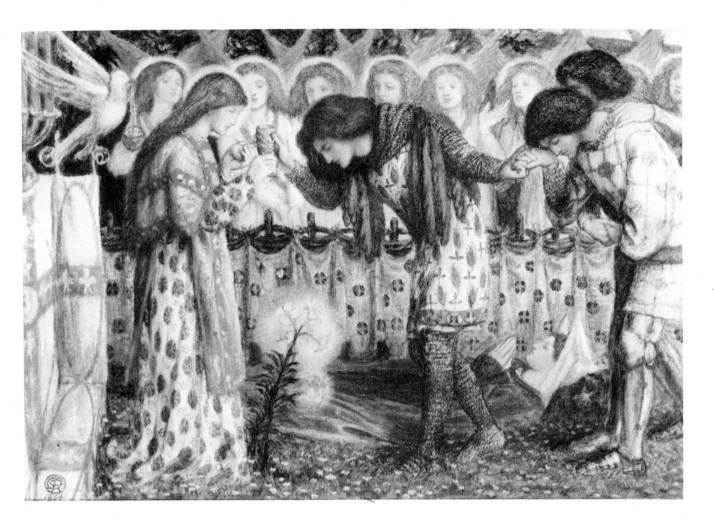

How Sir Galahad, Sir Bors and Sir Percival were Fed with The Sanc Grael; but Sir Percival's Sister Died by the Way. Water-colour, 11½″ × 16½″, 1864. (*The Tate Gallery, London*)

A finished painting after a design for a bay in the Oxford Union, never executed, showing Sir Galahad receiving the Holy Grail. Sir Percival, whose sister lies dead, follows behind.

From The Spectator, *January 6, 1883.*

Mr. Dante Gabriel Rossetti was by no means an artist without faults. To the calm perfection which marks the works of many of the older artists, he never attained. To the last, there was in his painting, his drawing, and his manner of conceiving his subject, many peculiarities,—we might almost say conventionalisms. What may be just noted briefly in this connection is that these conventionalisms were in the main original ones, and though, perhaps, something analogous to them may be found in early Italian Art, they were, in no sense of the word, imitations of the practices of previous painters. The strange physical peculiarities which many people find so trying in Rossetti's women, are due, by no means, to any defective knowledge on the part of the painter, and still less, as we hold, to any deliberate affectation. It is perfectly easy to find in his poetry, as it was to see in his house and its furniture, that his mind consistently ran in a strange groove of mediaevalism; and he chose the types of womanhood, and accentuated their peculiarities, which he found would best serve the purpose of his art. If there is one thing more certain about his paintings than another, so certain that even a second Belt jury would have to consider it, it is that their feeling is entirely natural and spontaneous. If ever a "passive master lent his hand," that master was Rossetti; and in looking at his work, one is chiefly possessed by the fact of its mastery over the man who executed it. This is not the painting of an Englishman of the present day, who is looking to mediaeval Italy and trying to paint like its artists; it is the work of a man who in thought and feeling (as half by birth) is an Italian to the core, and who has so saturated himself with the literature, poetry, and religion of his countrymen of ancient times, that his real life is more that of Florence in the fourteenth, than London in the nineteenth, century. Had we space, it were interesting to compare him with Mr. Burne Jones, who wears his "rue with a difference," and

try to show the discrepancies and similarities of their art; but here we can only pause to point out the great vital distinction between them. Mr. Burne Jones is a painter of the present, who regrets the past; Mr. Rossetti was a painter of the past, who ignored the present. By this, we do not mean that Mr. Burne Jones takes his subjects from the present, that is well known not to be the case; but that when he paints his old-world themes, he does so as a Modern, with a half-sick regret that they are past. But to Rossetti, they are not only alive, they are the only verities living. And this springs from the difference of what is sought to be represented. The living artist is wedded to the *form* of ancient life, as evidenced in the dresses, the architecture, the quaint-nesses of movement, the peculiar, half-allegorical manner of representing it, which was adopted by the elder Italian painters, and with all these things he seeks to make his canvas beautiful. That is his aim. But Rossetti does not think about his ancient life at all, does not think very much about making a beautiful picture. What he does consider is how to tell something as truly as possible. That he tells it in terms of antiquity is owing to his being,—Rossetti. But, with him, truth means truth of emotion, and if he can gain that, he will surrender to it all else. He is, perhaps, the only painter in the world who deliberately works in the same picture on two totally distinct lines, the natural and the conventional, and succeeds in combining them without offence. The conventionalities which he introduces are so dramatically and emotionally natural, that the mind accepts them frankly, and, recognising their aid in enforcing the meaning of the picture, would not, if it could, have any more consistent treatment. In a matter like this, a painter's method must be judged by its results; and if the result is beautiful, the justification is complete. One other point must be mentioned, before we speak of this more fully. We have not yet used the obnoxious word "pre-Raphaelite" in this article, but we must do so now, if only to remind our readers that in connection with that celebrated word and the brotherhood it denoted, one charge has been frequently made, and maintained up to the present time. It was said that, alike in the painting and the poetry of the school and its followers, there was an unhealthy exaltation of the sensual side of love. Without stopping to discuss that, let us ask if this can be alleged as against Rossetti's pictures. Taking them as a whole, the answer is most certainly, "No." And yet a very slight variation in the form of the question would necessitate a different answer, for never in the whole course of Art has there been a large collection of works by one painter in which the subject was so com-pletely limited to various phases of love. It will be found, however, that in each of those pictures which represents a love-scene (and there are very many) it is, in so many words, an impossibility to think of the painter as taking a sensual view of his subject. From the whole Beatrice series, to that wonderful picture of "Found", which represents an incident of our own day, Mr. Rossetti's love pictures are free from any sensual or morbid suggestion, unless it be, as perhaps some would have us think, morbid to paint this matter at all. We should be disposed to say that as a painter of love and lovers, this art of which we are speaking has never been exceeded, perhaps never even approached. We know no corresponding paintings at once so free from exaggeration and defect of the sexual passion, they are neither ascetic nor sensual, but preserve the perfect and healthy balance of manhood and womanhood. To this must be added the remark that the larger single figures, in which no story is told, are not, perhaps, quite free from the charge above mentioned. Their luxuriance of beauty, their full lips, their masses of hair, their brilliancy of colouring, are more akin to the women of Rubens than those of Raphael; and the main impression that they convey is one of perfect and somewhat sensuous loveliness. But even in these there is almost invariably to be found a meaning which is absolutely distinct from the above expression; and the majority of them are embodiments of some definite poetic conception. In truth, in all Mr. Rossetti's work, his aim is to embody some poetic idea, to express in terms of colour and form certain thoughts and emotions. We do not say that his view of the province of Art was absolutely the highest, we *do* say that it was warped by shortcomings which were the inevitable results of the painter's life, nationality, and mode of thought; but when all allowance is made for the possible faultiness of his conception, and the admitted drawbacks in the man-ner in which that conception was wrought out, what are we to say to the work as it stands? Simply that it forms the most lovely series of pictures which we have seen in the whole range of modern Art, and to find a parallel with which, we must go back to Italy and her greatest masters. There is not a single living colourist in Europe (we will give our readers Asia, Africa, and America, in), whose pictures would not look cold and clay-like, if placed in this gallery; there is not a single colourist the world has ever seen, beside whose paintings some of these might not hang, and hold their own. We are not speaking hastily or in exaggeration in saying this; it is a literal fact that *there is no lovelier colour in existence* than that of which there are many specimens here. And here, before we close the article which touches the general view of Rossetti's Art, we must just note two of its other great merits, first amongst which is its power. There is not a feeble bit of work in the exhi-bition. Strange it is often, bizarre sometimes, but weak never. And again, its grace is very remarkable. The manner in which the position of the hands and arms and the poise of the head carry out the main idea has all the unstudied beauty of free, natural movement, as opposed to the manufactured grace of the schools. And, for a minor detail, the treatment of drapery has never in modern times been more successfully grappled with. From the slightest chalk sketches, to the most highly-finished oil pictures, the drapery is splendidly disposed and painted, with no small unmeaning folds, and still less with great, unbroken masses, such as used to mark what was called the "grand style." As a last word, it is consolatory to find that nine-tenths of the visitors to Burlington House pass through the four large first galleries unheedingly, and collect in crowds in the little room where the Rossettis hang, crowded, but triumphant.

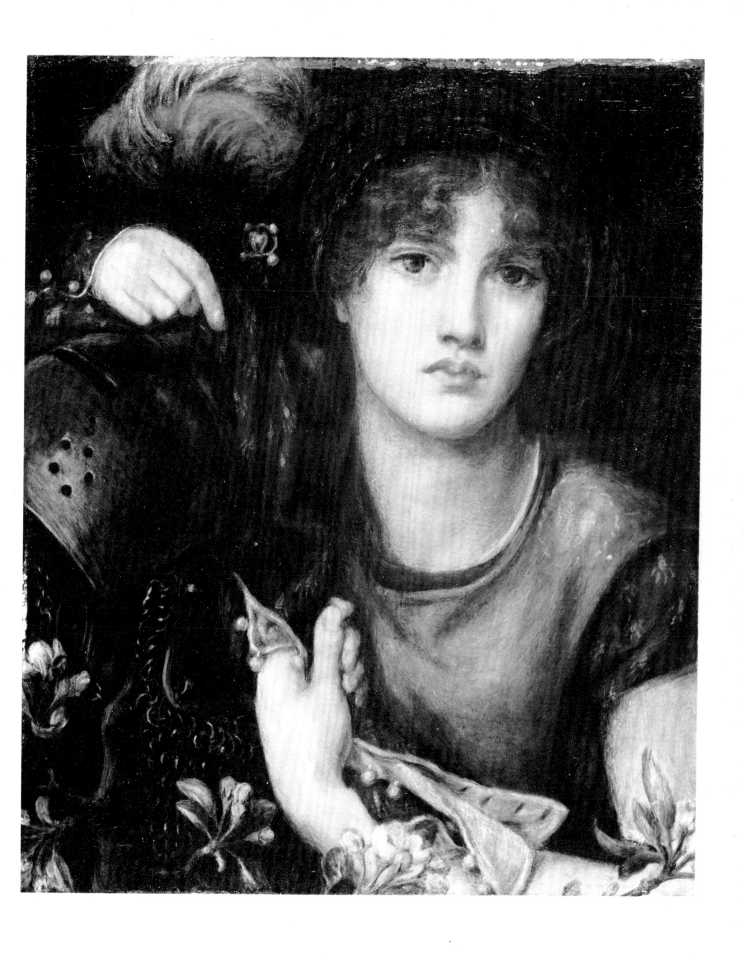

My Lady Greensleeves. Oil on panel, 13″ × 10¾″, 1863. (*The Fogg Museum of Art, Harvard University*)

45

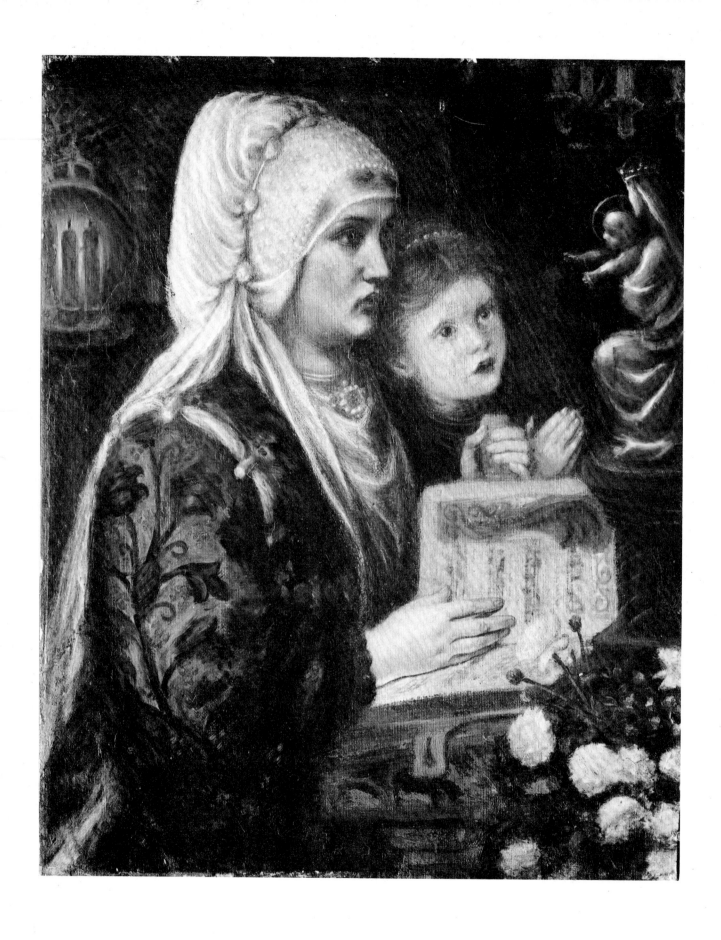

Two Mothers. Oil, 12″ × 10⅛″, 1852. (*Walker Art Gallery, Liverpool*)

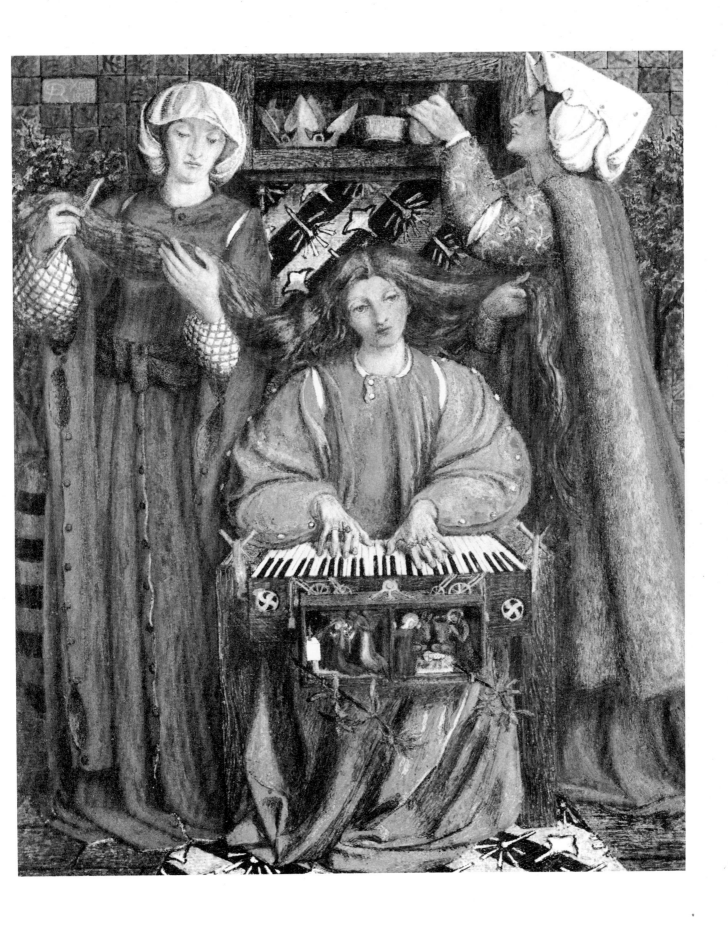

A Christmas Carol. Water-colour on panel, $13\frac{1}{4}'' \times 11\frac{1}{2}''$, 1857–58. (*The Fogg Museum of Art, Harvard University*)

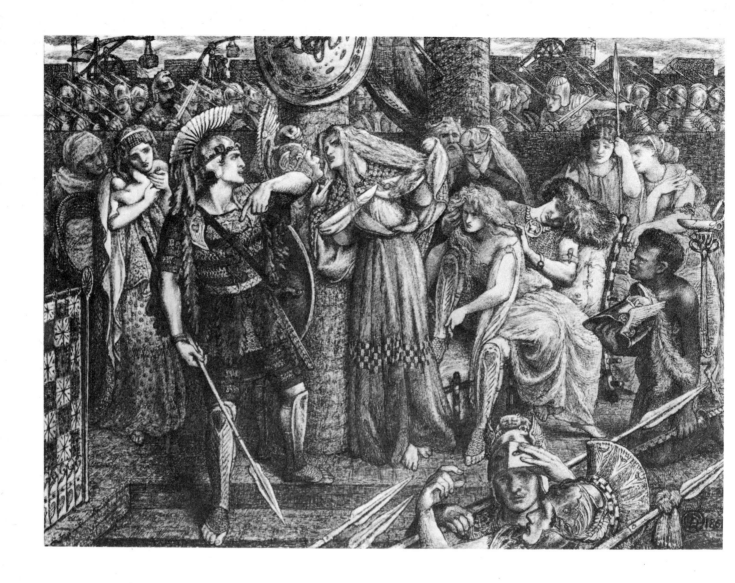

Cassandra. Pen and ink, 13″ × 18½″, 1861. (*The British Museum, London*)

Rossetti explained the action in this composition in a letter to his friend Charles Eliot Norton in April, 1869: "I send you herewith some photos – chiefly from uncoloured drawings. The *Cassandra* subject I hope one day to paint. I mean her to be prophesying the death of Hector before his last battle. He will not be deterred from going, and rushes at last down the steps, giving an order across her noise to the Captain in charge of the soldiers who are going around the ramparts on their way to battle. Cassandra tears her garments in rage and despair. Helen is arming Paris in a leisurely way, and he is amused at the gradual rage she is getting into at what Cassandra says of her. Other figures are Andromache with Hector's child, the Nurse, Priam and Hecuba, and one of the Brothers who is expostulating with Cassandra. Hector's companions have got down the steps before him, and are beckoning him to follow . . . " Finding a satisfactory model for Hector's child was apparently something of a problem, and Rossetti enlisted the help of his mother in the search, writing to her, "The baby you sent me has fallen ill and cannot sit. Would you do me the great service of trying to send one another as soon as possible. The last did very well in size and make, so another to something of the same pattern would answer."

CASSANDRA

(For a Drawing)

I

Rend, rend thine hair, Cassandra: he will go.
 Yea, rend thy garments, wring thine hands, and cry
 From Troy still towered to the unreddened sky.
See, all but she that bore thee mock thy woe:—
He most whom that fair woman arms, with show
 Of wrath on her bent brows; for in this place
 This hour thou bad'st all men in Helen's face
The ravished ravishing prize of Death to know.

What eyes, what ears hath sweet Andromache,
 Save for her Hector's form and step; as tear
 On tear make salt the warm last kiss he gave?
He goes. Cassandra's words beat heavily
 Like crows above his crest, and at his ear
 Ring hollow in the shield that shall not save.

II

'O Hector, gone, gone, gone! O Hector, thee
 Two chariots wait, in Troy long bless'd and curs'd;
 And Grecian spear and Phrygian sand athirst
Crave from thy veins the blood of victory.
Lo! long upon our hearth the brand had we,
 Lit for the roof-tree's ruin: and to-day
 The ground-stone quits the wall,—the wind hath way,—
And higher and higher the wings of fire are free.

O Paris, Paris! O thou burning brand,
 Thou beacon of the sea whence Venus rose,
Lighting thy race to shipwreck! Even that hand
 Wherewith she took thine apple let her close
 Within thy curls at last, and while Troy glows
Lift thee her trophy to the sea and land.'

1870

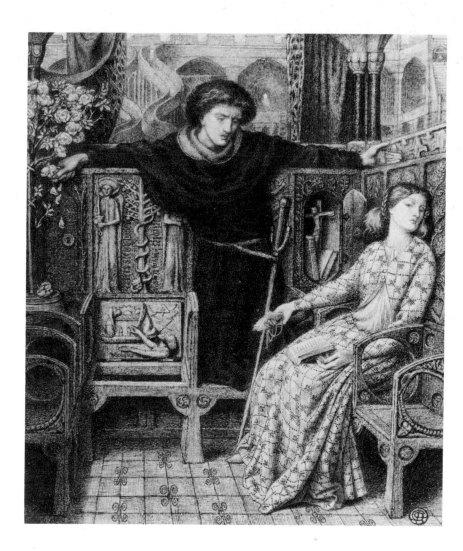

Hamlet and Ophelia. Pen and ink,
12″ × 10½″, 1858. (*The British Museum,
London*)

49

Beatrice is gone up into high Heaven,
 The kingdom where the angels are at peace;
 And lives with them: and to her friends is dead.
Not by the frost of winter was she driven
 Away, like others; nor by summer-heats;
 But through a perfect gentleness, instead.
 For from the lamp of her meek lowlihead
Such an exceeding glory went up hence
 That it woke wonder in the Eternal Sire,
 Until a sweet desire
Entered Him for that lovely excellence,
 So that He bade her to Himself aspire;
Counting this weary and most evil place
Unworthy of a thing so full of grace.

Wonderfully out of the beautiful form
 Soared her clear spirit, waxing glad the while;
 And is in its first home, there where it is.
Who speaks thereof, and feels not the tears warm
 Upon his face, must have become so vile
 As to be dead to all sweet sympathies.
 Out upon him! an abject wretch like this
May not imagine anything of her—
 He needs no bitter tears for his relief.
 But sighing comes, and grief,
And the desire to find no comforter,
 (Save only Death, who makes all sorrow brief,)
To Him who for a while turns in his thought
How she hath been among us, and is not.

With sighs my bosom always laboureth
 In thinking, as I do continually,
 Of her for whom my heart now breaks apace;
And very often when I think of death,
 Such a great inward longing comes to me
 That it will change the colour of my face;
 And, if the idea settles in its place,
All my limbs shake as with an ague-fit:
 Till, starting up in wild bewilderment,
 I do become so shent
That I go forth, lest folk misdoubt of it.
 Afterward, calling with a sore lament
On Beatrice, I ask 'Canst thou be dead?'
And calling on her, I am comforted.

Study for **Beata Beatrix.** Pencil, 5½″ × 4½″. (*William Morris Gallery, Walthamstow*)

From Dante's *Vita Nuova* translated by D. G. Rossetti, 1861.

Beata Beatrix. Oil, 34″ × 26″, 1864. (*The Tate Gallery, London*)

Rossetti began this painting a few years before the death of his wife, who sat for it. He rediscovered and decided to complete it in 1863 as a symbolic treatment of the death of Beatrice, the moment of her transition from Earth to Heaven. She sits at a balcony in a trance-like state, growing conscious of the world she is about to enter. The sundial reads nine o'clock, the hour of her death and a significant number in the *Vita Nuova*. In the background Dante encounters the figure of Love in the city which he found so desolate after Beatrice's death – "After this most gracious creature had gone out from among us, the whole city came to be as it were widowed and despoiled of dignity."

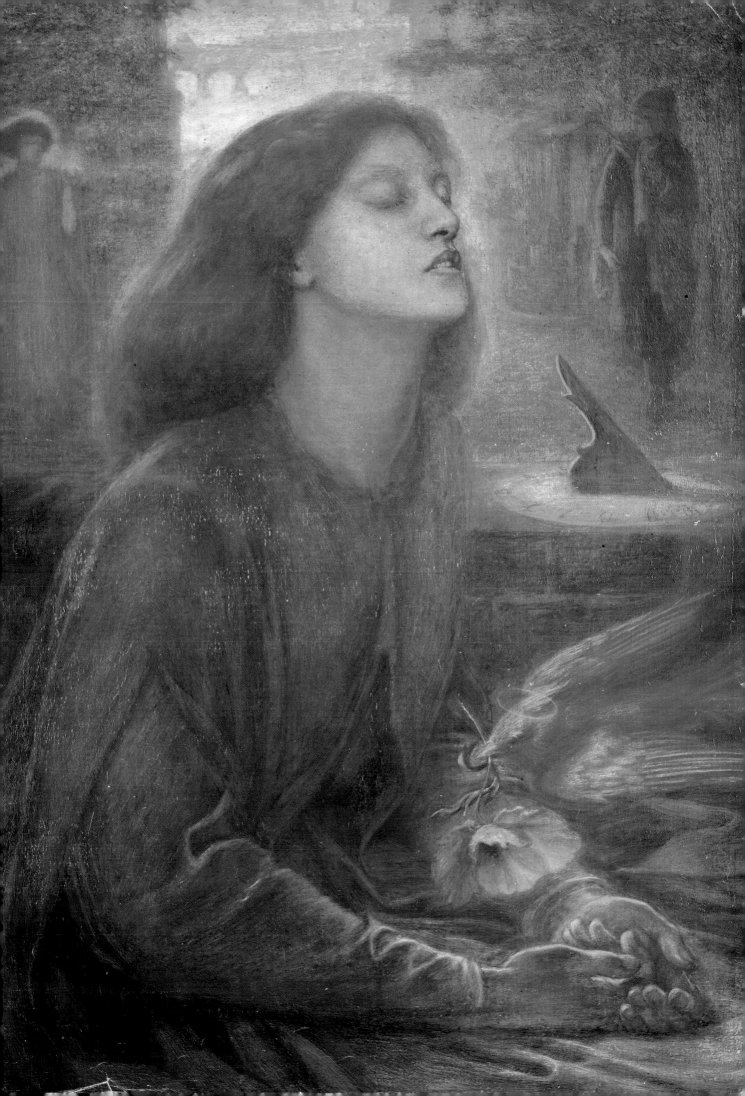

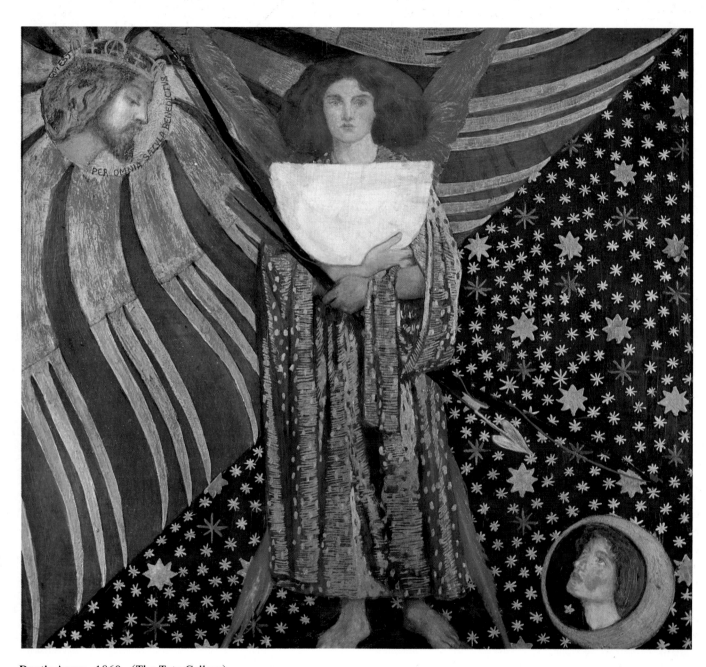

Dantis Amor. 1860. (The Tate Gallery).

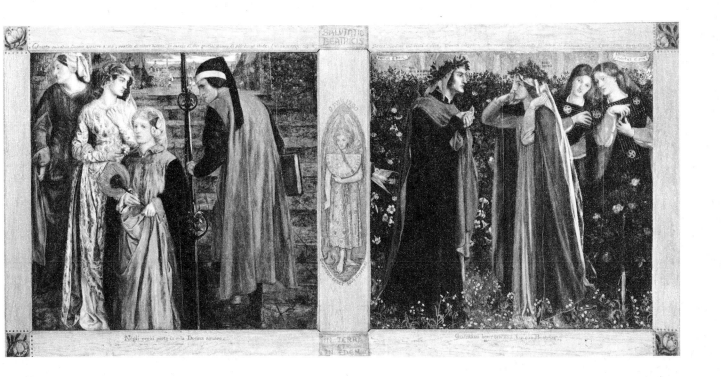

The Salutation of Beatrice. Oil on two panels, each 29½″ × 31½″, 1859. (*The National Gallery of Canada, Ottawa*)

"I have done a whole picture in a week on one of Topsy's doors", Rossetti wrote to Ford Madox Brown in June, 1859. The wild state of William Morris's hair, like that of the slave girl in *Uncle Tom's Cabin*, had earned him the nickname "Topsy". The "picture" decorated a cabinet at the Morris home, The Red House, Bexley Heath. When the house was abandoned in 1865 the panels were removed and framed together. The three women in the left-hand panel are Mrs. Morris, Fanny Cornforth and "Red Lion Mary", who had been housekeeper for Burne-Jones and Morris at Red Lion Square. In August, 1863, Rossetti described the work in a letter to Ernest Gambart: "The first subject is the earliest meeting of Dante with Beatrice in Florence, after they had arrived at years of manhood and womanhood. The incident is described in Dante's *Vita Nuova*, and the quotation above my painting says (in English) 'This wonderful lady appeared to me, dressed in white, between two gentle ladies older than herself.' The line underneath is from one of the sonnets contained in the *Vita Nuova* and says, 'My lady carries love within her eyes.' Between the two subjects, the figure painted in gold on the frame, represents Love holding the sundial, with the shadow falling on the hour of 9 at which Beatrice died, as Dante tells us, on the 9th of June, 1290, which date is above; and Love is extinguishing his torch as a symbol of her death. Beneath is the passage from Jeremiah, which Dante quotes in Latin, in the *Vita Nuova*, where he speaks of his great grief at her death: 'How doth the city sit solitary!' This figure shows the death of Beatrice to take place between the two subjects. The second subject is Dante's meeting with Beatrice in Eden, after her death as described by him in the 30th Canto of the second part of the *Divina Commedia*. 'With a white veil and a wreath of olive, a lady appeared to me wearing a green mantle over a dress of the colour of living flame.' The line underneath is what she says to him: 'Look on me well; I indeed, I indeed am Beatrice.' In the picture, Dante is intended to have just raised his face in his hands in which he has hidden it, to look at Beatrice when she unveils. The subjects are treated from the real and not the allegorical side of Dante's love story . . ."

Dantis Amor. Oil on panel, 29½″ × 32″, 1860. (*The Tate Gallery, London*)

The unfinished centre panel for Morris's cabinet at The Red House (see *The Salutation of Beatrice*).

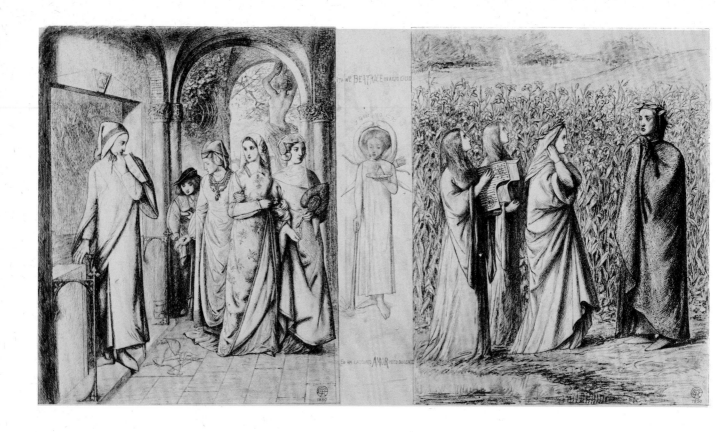

Study for **The Salutation of Beatrice.** Pen and ink and wash, 14⅛″ × 26⅛″, 1849–50. (*The Fogg Museum of Art, Harvard University*)

After the lapse of so many days that nine years exactly were completed since the above-written appearance of this most gracious being, on the last of those days it happened that the same wonderful lady appeared to me dressed all in pure white between two gentle ladies elder than she. And passing through a street, she turned her eyes thither where I stood sorely abashed: and by her unspeakable courtesy, which is now guerdoned in the Great Cycle, she saluted me with so virtuous a bearing that I seemed then and there to behold the very limits of blessedness. The hour of her most sweet salutation was exactly the ninth of that day; and because it was the first time that any words from her reached mine ears, I came into such sweetness that I parted thence as one intoxicated. From Dante's *Vita Nuova* translated by D. G. Rossetti, 1861.

Hesterna Rosa. Pen and ink, 7½″ × 9¼″, 1853. (*The Tate Gallery, London*)

Rossetti described this drawing in a letter to Edmund Bates in October, 1879: "The *Hesterna Rosa* (or *Yesterday's Rose*) might have for a motto these lines of Henry Taylor's:
Quoth tongue of neither maid nor wife
To heart of neither wife nor maid–
'Lead we not here a jolly life
Betwixt the shine and shade?'
Quoth heart of neither maid nor wife
To tongue of neither wife nor maid–
'Thou wagg'st, but I am worn with strife,
And feel like flowers that fade.'
The scene might be described as an orgy wearing towards dawn in a lamp-lit court. The principal figure is the weary girl who presses her fingers to her brows behind the kneeling weasel-faced gamester. The other man, who looks a better sort, has got hold of a riotous, unwearied mate, as dark things generally go by contraries in life of that order."

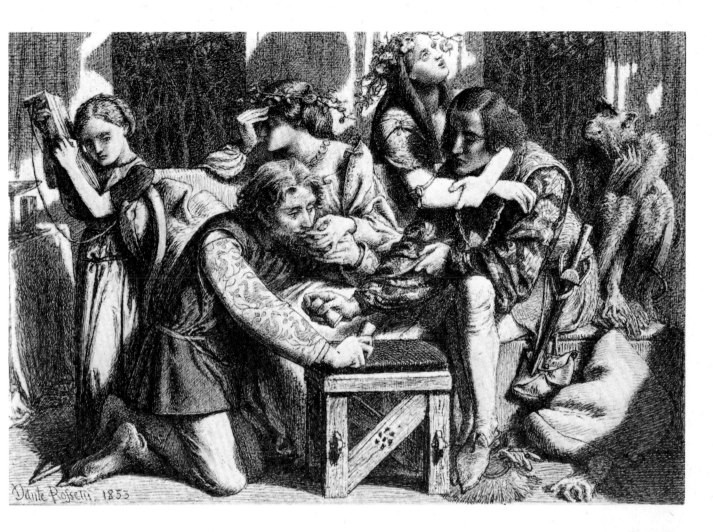

Hesterna Rosa.

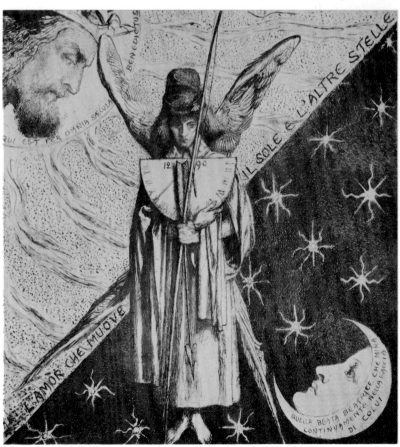

Study for **Dantis Amor.** Pen and brown ink, 9⅞″×9½″, c. 1860. (*Birmingham City Museum and Art Gallery*)

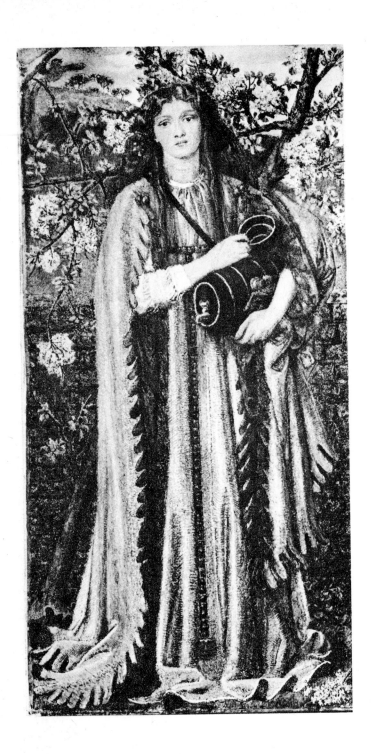

Golden Water. Water-colour, $14\frac{1}{2}'' \times 17\frac{1}{4}''$, 1858.
(*The Fitzwilliam Museum, Cambridge*)

SIBYLLA PALMIFERA

(For a Picture)

Under the arch of life, where love and death,
 Terror and mystery, guard her shrine, I saw
 Beauty enthroned; and though her gaze struck awe,
I drew it in as simply as my breath.
Hers are the eyes which, over and beneath
 The sky and sea bend on thee,—which can draw,
 By sea or sky or woman, to one law,
The allotted bondman of her palm and wreath.

This is that Lady Beauty, in whose praise
 Thy voice and hand shake still,—long known to thee
 By flying hair and fluttering hem,—the beat
 Following her daily of thy heart and feet,
 How passionately and irretrievably,
In what fond fight, how many ways and days!

1870

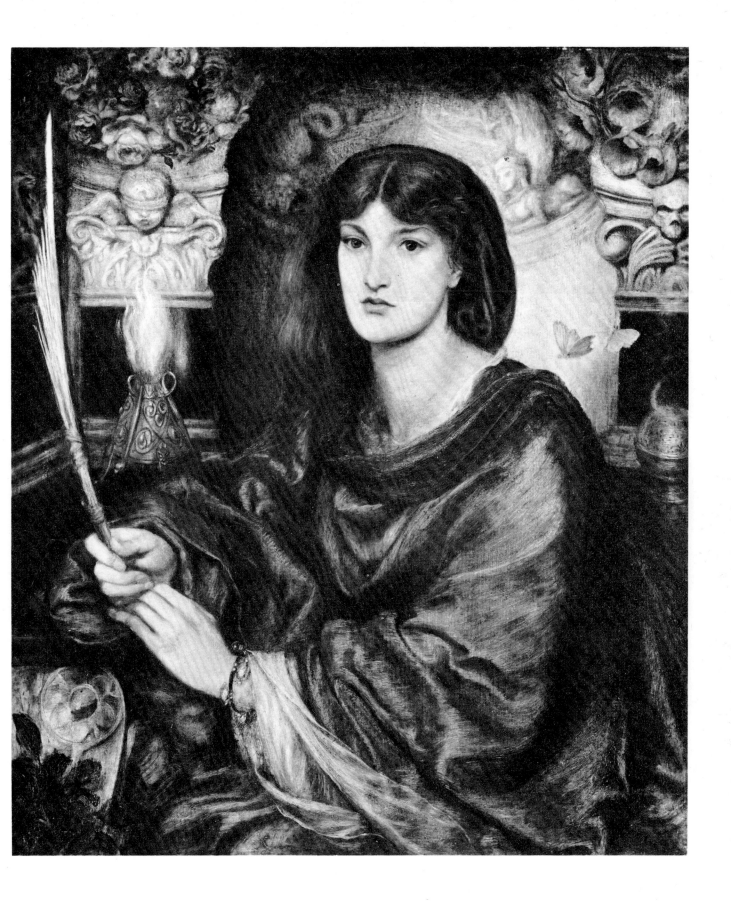

Sibylla Palmifera. Oil, 37″×32½″, 1866–70. (*The Lady Lever Art Gallery, Port Sunlight*)

Rossetti gave this title to the painting "to mark the leading place which I intend her to hold among my beauties." The sitter is Alexa Wilding, representing 'Soul's Beauty', to be contrasted with another painting, *Body's Beauty* or *Lilith*, for which Fanny Cornforth sat.

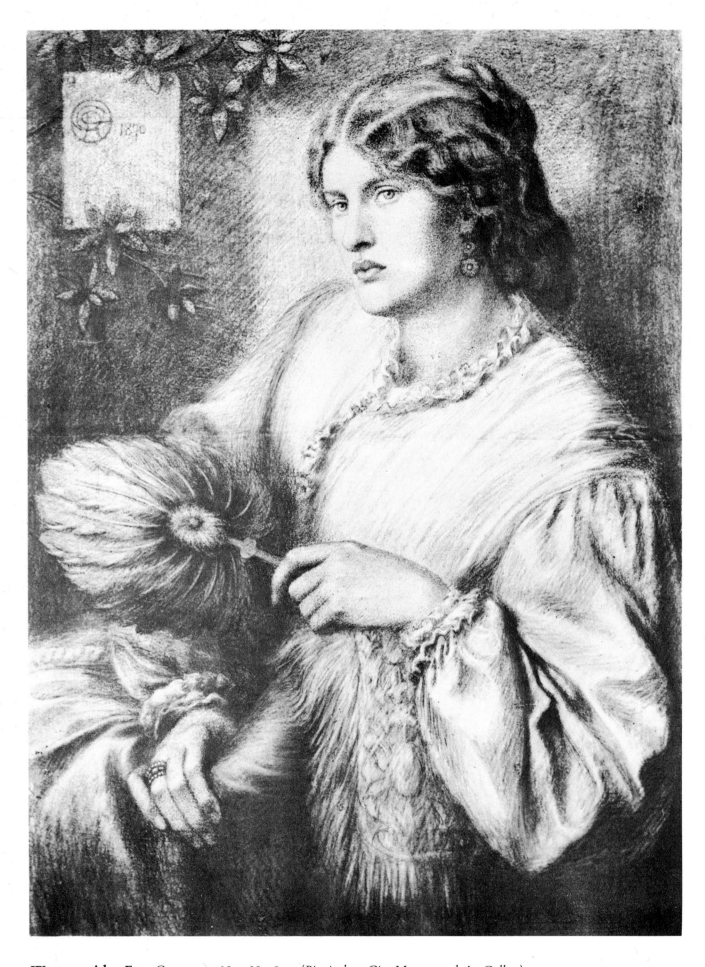

Woman with a Fan. Crayons, 37¾″×28″, 1870. (*Birmingham City Museum and Art Gallery*)

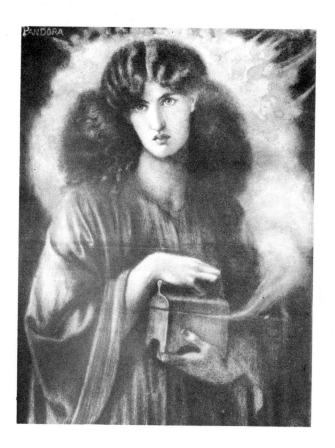

Study for **Pandora.** Coloured chalks, 39⅝″ × 28⅝″, 1869.

(*The Faringdon Collection Trustees, Buscot Park*)

Study for **Pandora.** Pen and brown ink, 6⅜ x 5 5/16″.

(*Birmingham City Museum and Art Gallery*)

In 1875 in *Essays and Studies* Swinburne wrote of this painting: "The design is among his mightiest in its godlike terror and imperial trouble of beauty, shadowed by the smoke and fiery vapour of winged and fleshless passions crowding round the casket in spires of flame-lit and curling cloud round her fatal face and mourning veil of hair". The model is Jane Morris.

P ANDORA
 (For a Picture)

What of the end, Pandora? Was it thine,
 The deed that set these fiery pinions free?
 Ah! wherefore did the Olympian consistory
In its own likeness make thee half divine?
Was it that Juno's brow might stand a sign
 For ever? and the mien of Pallas be
 A deadly thing? and that all men might see
In Venus' eyes the gaze of Proserpine?

What of the end? These beat their wings at will,
The ill-born things, the good things turned to ill,—
 Powers of the impassioned hours prohibited.
Aye, hug the casket now! Whither they go
Thou mayst not dare to think: nor canst thou know
 If Hope still pent there be alive or dead.

1870

59

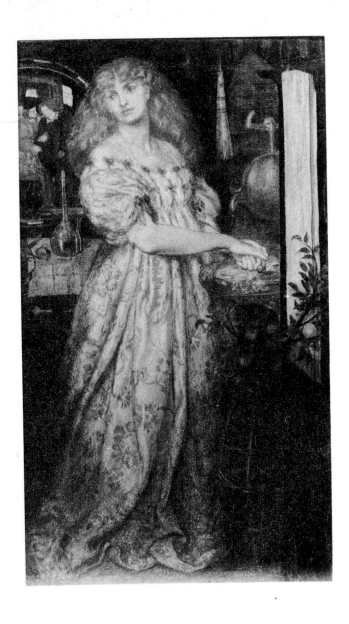

Lucrezia Borgia. Water-colour, 17″×9¾″, 1860–61.
(*The Tate Gallery, London*)

From The Athenaeum, *October 21, 1865.*

A third picture is entitled *Beloved,* and represents a bride with five attendants going to meet her groom. This work is somewhat less purely lyrical than the preceding, inasmuch as its subject is defined; it does not, however, rely merely upon a dramatic form for effect. What may be considered as its theme is derived from the Song of Solomon, "Let him kiss me with the kisses of his mouth; for thy love is better than wine." As intimated by the context of this passage, she is supposed to be approaching the lord. Coming near, she draws from before her face, with a graceful action of both hands, the bridal veil of blue and white that was gathered about her head, so that the beautiful countenance is displayed in all its pride of ivory-white; the lately-startled blush appears to spread from chin to brow; that brow is crowned by a geranium-coloured and golden aigrette on each temple, which spreads fan-like, and trembles as she moves. Beautiful, and conscious of beauty, she is without the pride of loveliness or the desire for power; the eyes are full of love; the lips are undeveloped roses, rich in life. The subtle rendering of expression, upon which the picture relies for much of its effect, is admirable, and thoroughly original in its tenderness. The beautiful drawing of the features, solidly modelled as they are, and that of the hands and swan-like neck, would be remarkable in a production of any school, and is still more so in that of England, where thoroughness in this respect is rare indeed. Her body-robe is of silk, apple-green, of infinite variety in its tints, embroidered with golden and red flowers, to produce a harmony of colouring which assorts in singular felicity with the dark, golden-bronze hue of the skin of one of the attendants—a little negro girl, who stands in front, preceding the lady's steps. This servant's black hair and tawny skin form an admirable contrast to the fairness of the bride, the apple-green and the rich sheen of a golden vase wherein she bears the typical roses of the text. Four maidens of diverse tints group themselves behind their chief, and bear branches of trees and flowers above her head. With the foliage, these faces form a background to the figure of the bride, and their beauties supply so many foils to her beauty.

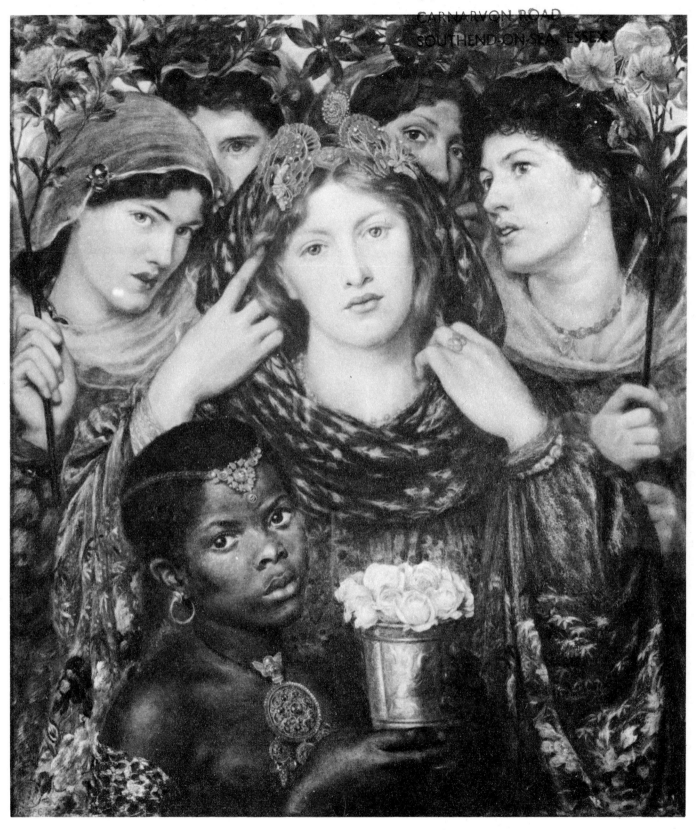

The Beloved. Oil, 32½″ × 30″, 1865–6. (*The Tate Gallery, London*)

"She shall be brought unto the King in raiment of needlework; the virgins that be her fellows shall bear her company" (Song of Solomon). This painting, also known as *The Bride*, was originally intended to be a Beatrice, but the colouring of the model, Marie Ford, led Rossetti to change his conception. A black boy was substituted for a mulatto girl in the course of the work.

Study for **The Beloved.** Black chalk and pencil, 19⅞″ × 14¼″, c. 1864–5. (*Birmingham City Museum and Art Gallery*)

Study for **The Beloved.** Pencil, 17″ × 12½″, 1865. (*The Tate Gallery, London*)

Study for **The Beloved.** Black chalk and pencil, 16¼″ × 12¼″. (*Birmingham City Museum and Art Gallery*)

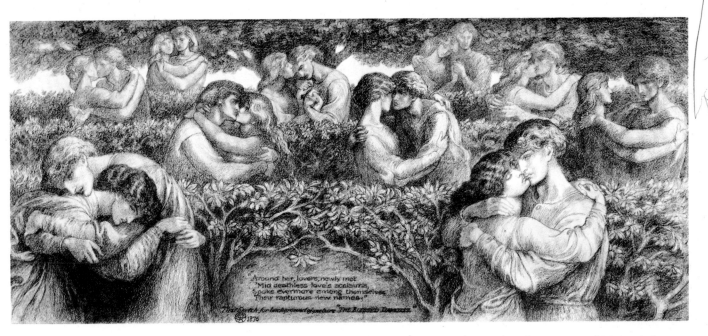

Study for **The Blessed Damozel.** Black and red chalk, 15¼″ × 36½″, 1876. (*The Fogg Museum of Art, Harvard University*)

Study for **Rosa Triplex.** Red, white, and black chalk, 20″ × 29″, 1867. (*The Tate Gallery, London*)

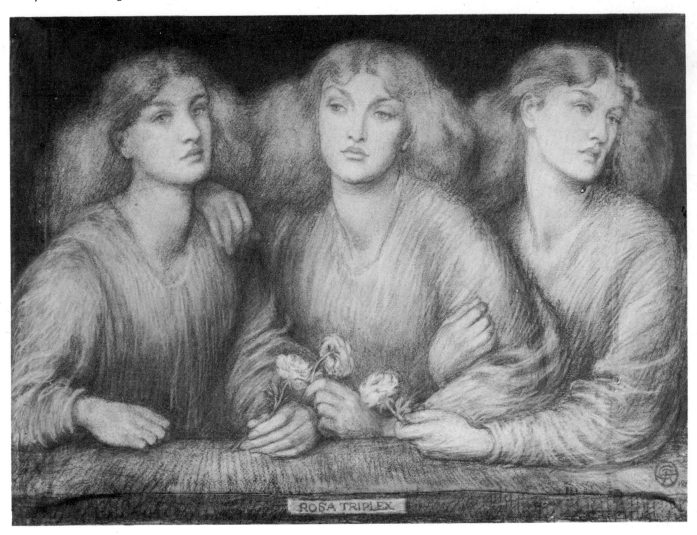

ROSA TRIPLEX

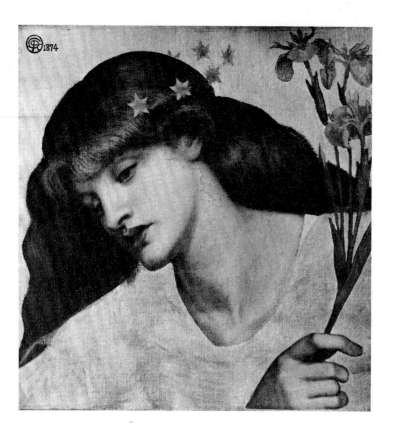

Sancta Lilias. Oil on panel, 19″ × 18″, 1874.
(*The Tate Gallery, London*)

THE BLESSED DAMOZEL

The blessed damozel leaned out
 From the gold bar of Heaven;
Her eyes were deeper than the depth
 Of waters stilled at even;
She had three lilies in her hand,
 And the stars in her hair were seven.

Her robe, ungirt from clasp to hem,
 No wrought flowers did adorn,
But a white rose of Mary's gift,
 For service meetly worn;
Her hair that lay along her back
 Was yellow like ripe corn.

Herseemed she scarce had been a day
 One of God's choristers;
The wonder was not yet quite gone
 From that still look of hers;
Albeit, to them she left, her day
 Had counted as ten years.

(To one, it is ten years of years.
 . . . Yet now, and in this place,
Surely she leaned o'er me—her hair
 Fell all about my face
Nothing: the autumn fall of leaves.
 The whole year sets apace.)

It was the rampart of God's house
 That she was standing on;
By God built over the sheer depth
 The which is Space begun;
So high, that looking downward thence
 She scarce could see the sun.

It lies in Heaven, across the flood
 Of ether, as a bridge.
Beneath, the tides of day and night
 With flame and darkness ridge
The void, as low as where this earth
 Spins like a fretful midge.

Around her, lovers, newly met
 In joy no sorrow claims,
Spoke evermore among themselves
 Their rapturous new names;
And the souls mounting up to God
 Went by her like thin flames.

And still she bowed herself and stooped
 Out of the circling charm;
Until her bosom must have made
 The bar she leaned on warm,
And the lilies lay as if asleep
 Along her bended arm.

From the fixed place of Heaven she saw
 Time like a pulse shake fierce
Through all the worlds. Her gaze still strove
 Within the gulf to pierce
Its path; and now she spoke as when
 The stars sang in their spheres.

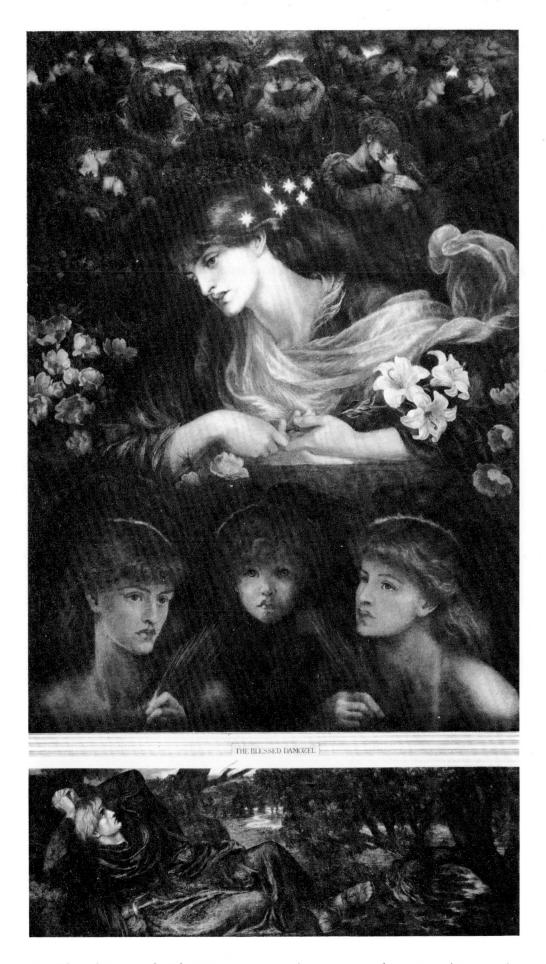

The Blessed Damozel. Oil, 68½″ × 37″, 1875–8. (*Fogg Museum of Art, Harvard University*)

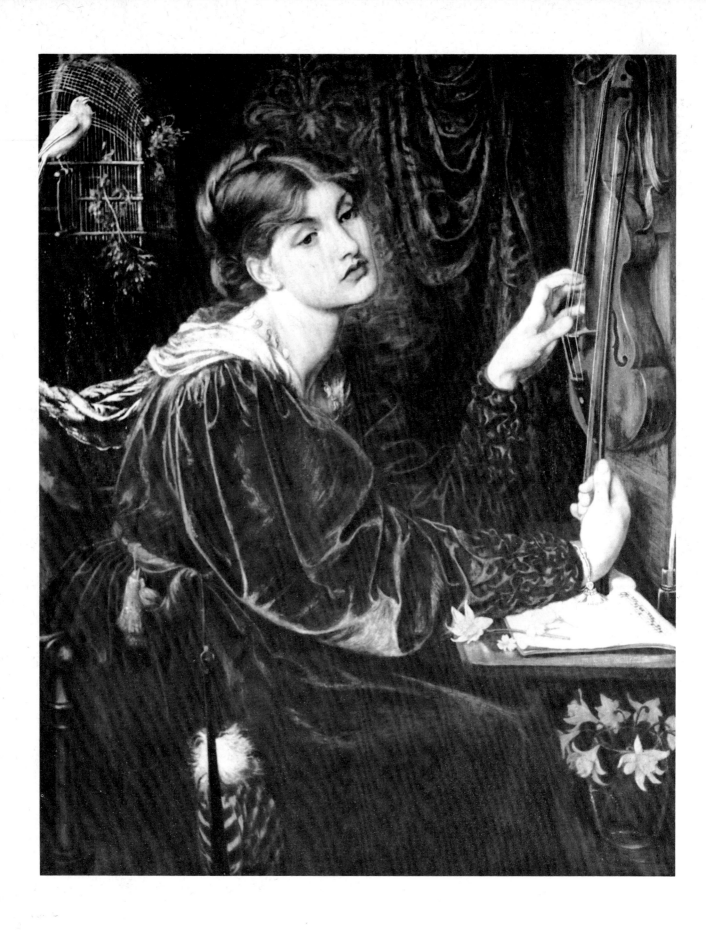

Veronica Veronese. Oil, 43″×35″, 1872. (*Samuel and Mary R. Bancroft Collection, Delaware Art Museum*)

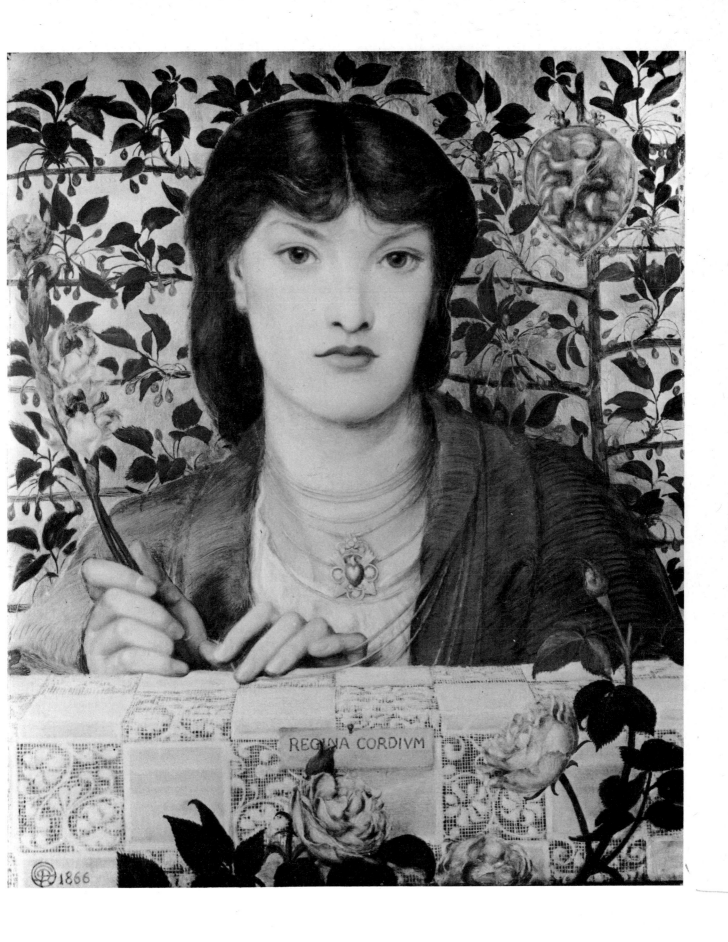

Regina Cordium. Oil, 23½″ × 19½″, 1866. (*Glasgow Art Gallery and Museum*)

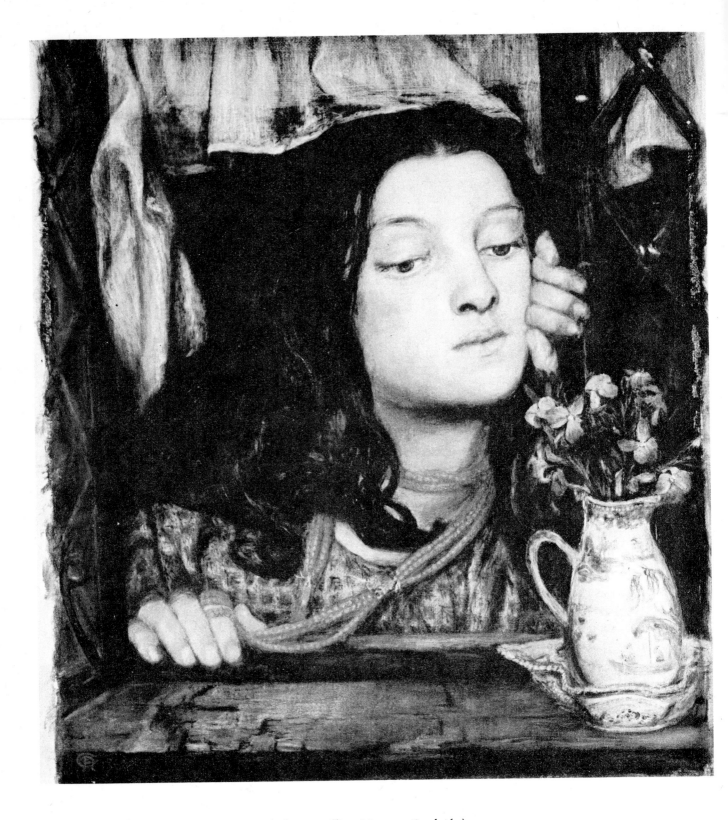

Girl at a Lattice. Oil, 11½″ × 10⅜″, 1862. (*The Fitzwilliam Museum, Cambridge*)

The Madox Browns' maid sat for this drawing, one of the first pieces of work Rossetti did after the death of his wife.

The Annunciation. Water-colour, 25¾″ × 10″, 1861. (*The Fitzwilliam Museum, Cambridge*)

The Morris Firm executed this design in oil for the pulpit of St. Martin's Church, Scarborough.

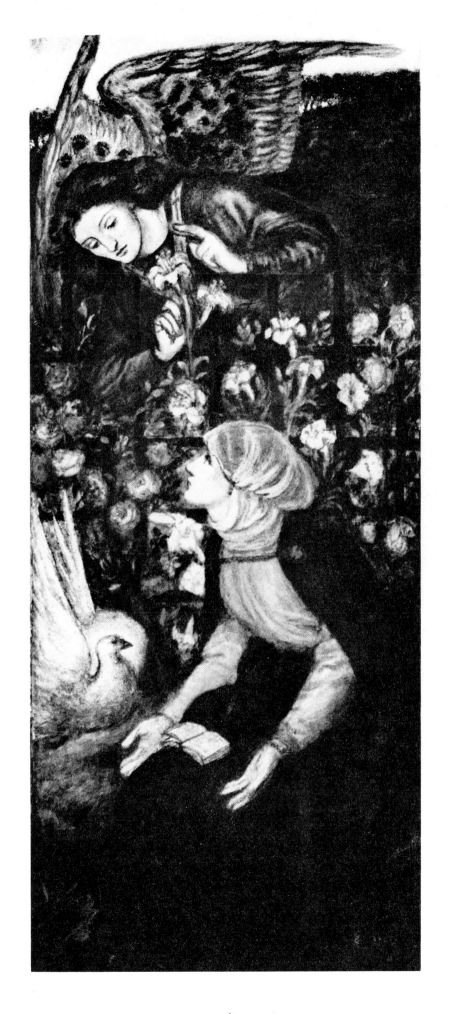

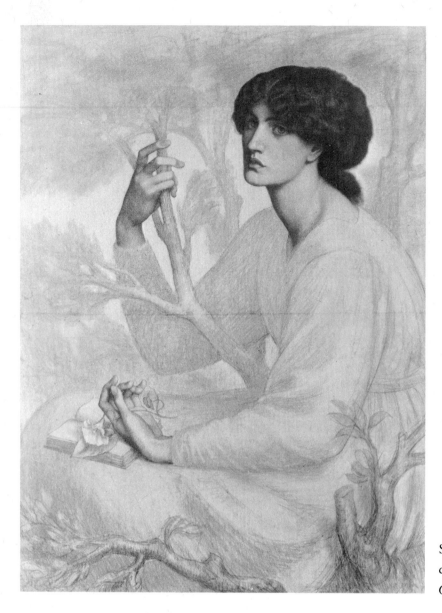

Study for **The Day Dream.** Pastel and black chalk, 41¼″ × 30¼″, 1878. (*Ashmolean Museum, Oxford*)

THE DAY-DREAM

(For a Picture)

The thronged boughs of the shadowy sycamore
 Still bear young leaflets half the summer through;
 From when the robin 'gainst the unhidden blue
Perched dark, till now, deep in the leafy core,
The embowered throstle's urgent wood-notes soar
 Through summer silence. Still the leaves come new;
 Yet never rosy-sheathed as those which drew
Their spiritual tongues from spring-buds heretofore.

Within the branching shade of Reverie
Dreams even may spring till autumn; yet non be
 Like woman's budding day-dream spirit-fann'd.
Lo! tow'rd deep skies, not deeper than her look,
She dreams; till now on her forgotten book
 Drops the forgotten blossom from her hand.

1881

The Day Dream. Oil, 62½″ × 36½″, 1880. (*Victoria and Albert Museum, London*)

This was Rossetti's favourite portrait of Jane Morris. Initially the title was *Monna Primavera* and Mrs. Morris held snowdrops in her hand. During the course of the work the seasons changed, honeysuckle was substituted, and the original title was no longer accurate.

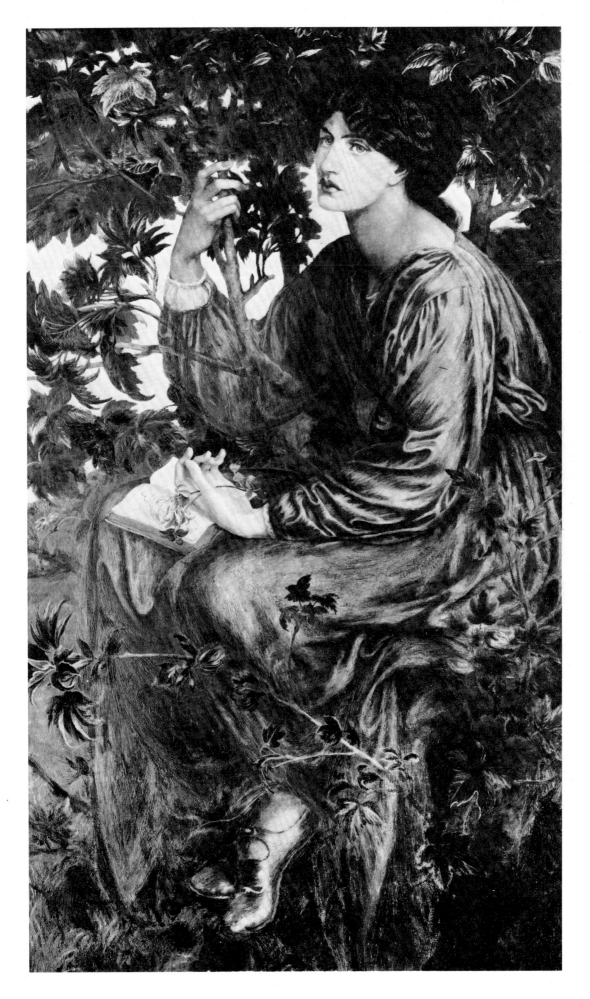

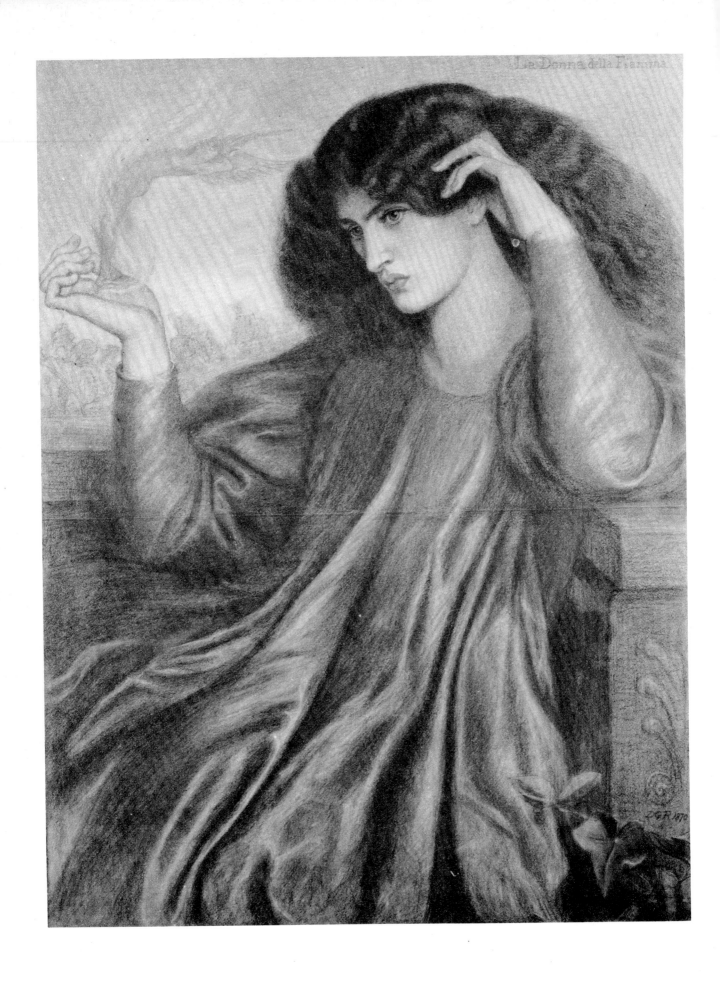

La Donna della Fiamma. Coloured chalks, 39⅝″×29⅝″, 1870. (*Manchester City Art Gallery*)

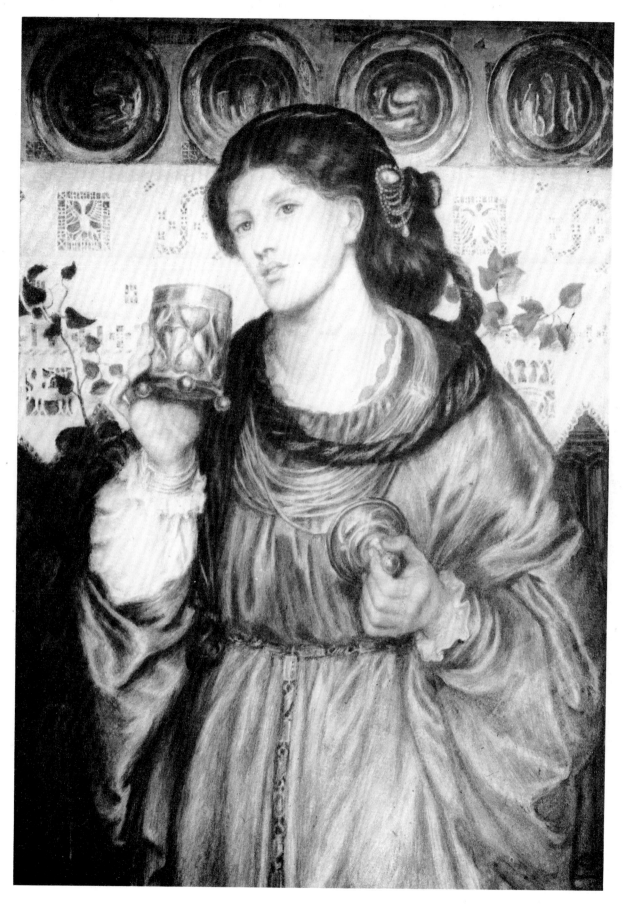

The Loving Cup. Water-colour, 20¾″ × 14″, 1867. (*William Morris Gallery, Walthamstow*)

The original painting, for which Alexa Wilding sat, was destroyed in the Second World War. Ellen Smith modelled for three replicas executed with the help of Henry Treffry Dunn, Rossetti's assistant, hired in 1867.

From a review of current shows published in Apollo, *May, 1948.*

. . . Rossetti managed to inspire the Pre-Raphaelite movement practically without ever becoming a Pre-Raphaelite. His swift Southern mind loved the conception of a picture, as his indolent Southern nature hated the long-drawn-out business of creation, especially creation after the conscientious painstaking manner of the group which his enthusiasm founded and named. The day was to come when he would declare that painting did not interest him because it was too easy. This was not the man to make detailed studies from nature of every item which went to the making of a picture. The truth is that few artists have had a less Pre-Raphaelite mind than Rossetti.

So we have the paradox of this leading spirit of the Brotherhood avoiding its practice, and escaping from it even before it escaped from him. For Holman Hunt was the one consistent Pre-Raphaelite. At Whitechapel we have from Rossetti no sizeable or important picture. It was, maybe, part of the diablerie of Dante Gabriel that, having raised the fury of the critics, he should so neatly disappear from view leaving them no target – except the canvases of his friends, victims, and adopted Brothers. He even gave a contemporary gossip-columnist the information of the meaning of their provocative title: a fact which infuriated the Millais family whose beloved *Jack* received the brunt of the campaign thus raised.

The works by Millais and by Holman Hunt at Whitechapel are excellent. Millais' magnificently drawn *Lorenzo and Isabella;* Hunt's *A Converted Christian Family sheltering a Christian Missionary from persecution by the Druids* (what a title!); Millais again with *The Blind Girl;* Hunt again with *The Scapegoat:* these are the outstanding classics of Pre-Raphaelitism. They are supported by a host of other paintings famous in the story of the school: Ford Madox Brown's *Last of England;* Burne-Jones' *Love among the Ruins;* Brett's *The Stonebreaker;* Arthur Hughes' *April Love.*

In this Exhibition the Pre-Raphaelite doctrine and achievement can thus be assessed. By the fashions of our time – albeit they show signs of a swing back, and their "New Look" is Victorian not only in the *modistes* but in the art galleries – they are concerned with all the wrong things: Story-telling, romantic literary subjects, exact copying from nature, finish. Neither that preoccupation with the effects of light which is our heritage from the Impressionists, nor the significant form bequeathed by Cézanne and his followers; nor the simplification, the Neo-primitivism, the subjectivism of the later schools finds the slightest place in these canvases and drawings. If there is anything to which our period would subscribe it is their keenness for bright colour which they attained by the use of white, even wet white undercoat painting. Not that this would win the suffrage of all modern practitioners, some of whom seem to have a strange "*nostalgie de la boue*" which at times appears to be the medium for their pigment.

It may well happen, however, that this centenary year of Pre-Raphaelitism coming just when fashion is on the rebound may lead us back spirally to a new acceptance of story-telling, careful finish, natural appearance, and less concern for the subjective with more for the subject. The time may be ripe for the rise of the Pre-Impressionists.

The fascination of Pre-Raphaelitism lies in its technical brilliance. It is arguable that it went off in the wrong direction, but at least it marched with firm steps. The actual drawing and painting in any Millais painting during his Pre-Raphaelite period, and in those of Holman Hunt throughout his life, of Ford Madox Brown or Burne-Jones, and those pictures of the lesser men, Hughes, Brett, Wallis, give delight by sheer conscientiousness and care. To our time it becomes a paradox to say that a drawing or a painting is good because it is literally true to life; but that theory is at the bottom of this group. And for all our high-falutin' modernism, why not? The hounds in Millais' *Lorenzo and Isabella* are true to a hair; the stones in Brett's *Stonebreaker* are each an individual study; the ivy leaves in Arthur Hughes' *April Love,* the Dead Sea salt flats in Holman Hunt's *Scapegoat:* everything in these works is a study from nature recognizably and uniquely itself. No wonder Ruskin was thrilled, for Ruskin's aesthetic creed demanded precisely that.

The curious thing was that these multitudinous units of nature never added up to nature: they made a thoroughly artificial art. The other curious phenomenon was that despite the preoccupation which these people had with poetry they achieved perfect prose. It was probably the poet in Rossetti which revolted. We must remember how great a part the exalted and poetic theme played in the principles of the school. The Bible, Shakespeare, and the Romantic poets, or equally moral and romantic situations from life, were to be their business. This urge for romance – the British equivalent to that earlier cry of the French Romantics: "Who will deliver us from the Greeks and the Romans?" – was really running counter to their own technique in painting which was eternally preoccupied with the facts of the case. That terrible prosy title of Holman Hunt's picture is a revelation of this inner struggle. The theme was exalted enough, but it reduced itself to sheerest prose when it was expressed. All this was part of the Victorian characteristic. It was a materialistic period, and never more so than when it thought it was dealing with things of the spirit. The Pre-Raphaelites suffered from this aspect of the times in which they lived. They are always in danger of Wardour Street in the exquisitely delineated costumes of their characters; and Keats' magic, Shakespeare's fantasy, or the significance of the Scriptures seeps away through the innumerable objects so perfectly depicted.

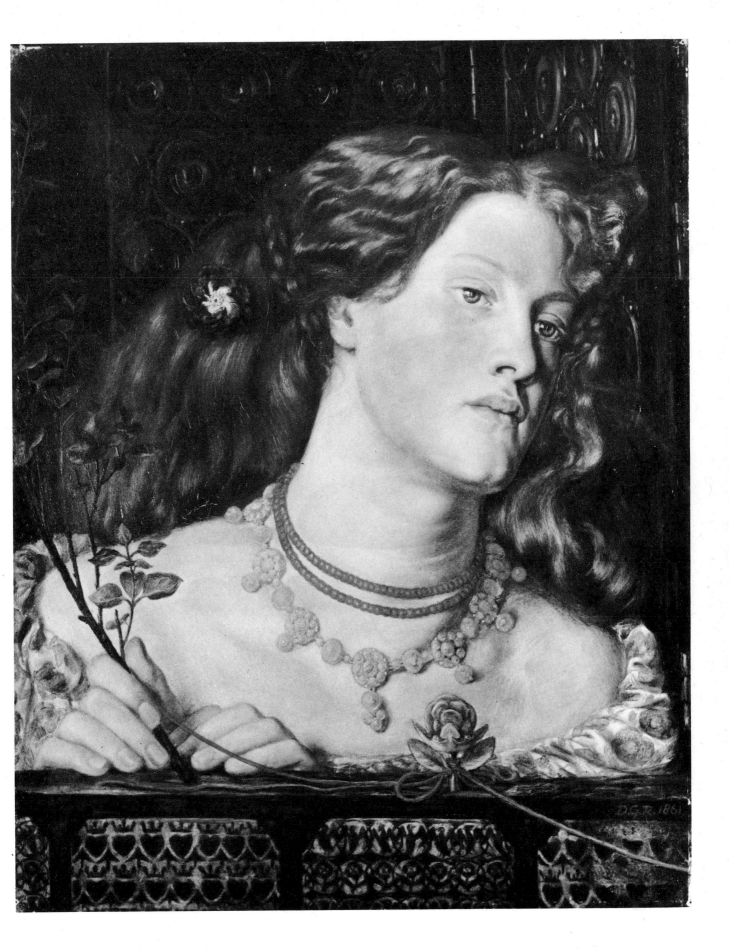

Fair Rosamund. Oil, 20½″ × 16½″, 1861. (*National Museum of Wales, Cardiff*)

Fanny Cornforth modelled for the study (p. 12) and the painting.

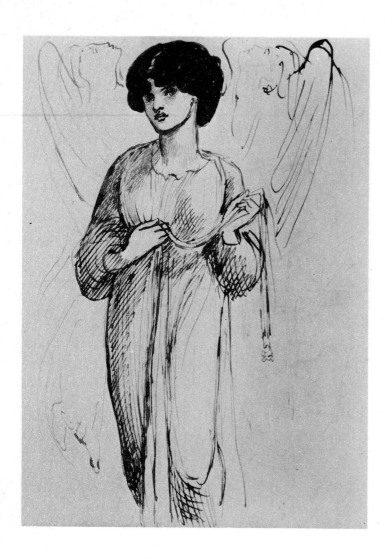

A STARTE SYRIACA

(For a Picture)

Mystery: lo! betwixt the sun and moon
 Astarte of the Syrians: Venus Queen
 Ere Aphrodite was. In silver sheen
Her twofold girdle clasps the infinite boon
Of bliss whereof the heaven and earth commune:
 And from her neck's inclining flower-stem lean
 Love-freighted lips and absolute eyes that wean
The pulse of hearts to the spheres' dominant tune.

Torch-bearing, her sweet ministers compel
 All thrones of light beyond the sky and sea
 The witnesses of Beauty's face to be:
That face, of Love's all-penetrative spell
Amulet, talisman, and oracle,—
 Betwixt the sun and moon a mystery.

1881

Study for **Astarte Syriaca.** Pen and brown ink, 9¼″×7″, c. 1875.
(*Birmingham City Museum and Art Gallery*)

Overleaf **Astarte Syriaca**, Oil, 72″×42″, 1877. (*Manchester City Art Gallery*)

Proserpine. Oil, 49¾″×24″, 1874. (*The Tate Gallery, London*)

When Pluto carried Proserpine off to Hades to be his empress, her mother, Ceres, begged Jupiter for her release. He agreed on the condition that Proserpine had not eaten any of the fruits of the Underworld, but she had tasted a pomegranate there and was consequently condemned to remain, except for a short period each year when she was permitted to ascend to earth. In the painting she stands in the gloomy palace holding the fruit that chained her to it. The incense burner beside her, Rossetti explained, is "the attribute of a goddess" and the ivy branch "a symbol of clinging memory". The theme of the myth – a woman granted only occasional periods of freedom from her husband – appealed to Rossetti, who probably felt it to be symbolic of his relationship with Jane Morris, who modelled for Proserpine. Rossetti originally conceived the painting as a picture of Eve holding the apple. Eight versions of it were done in all. "The vicissitudes of this blessed picture are as follows. I have begun it on seven different canvases – to say nothing of drawings. Three were rejected after being brought very forward. The fourth cost me a quarrel with Parsons . . . The fifth has twice had its glass smashed and renewed, and has twice been lined to remedy accidents. The sixth has had its frame smashed twice and its glass once, and was nearly rendered useless by an accident which happened while transferring it to a fresh strainer, and now has narrowly escaped total destruction." *From a letter to Ford Madox Brown, 6th January, 1874.*

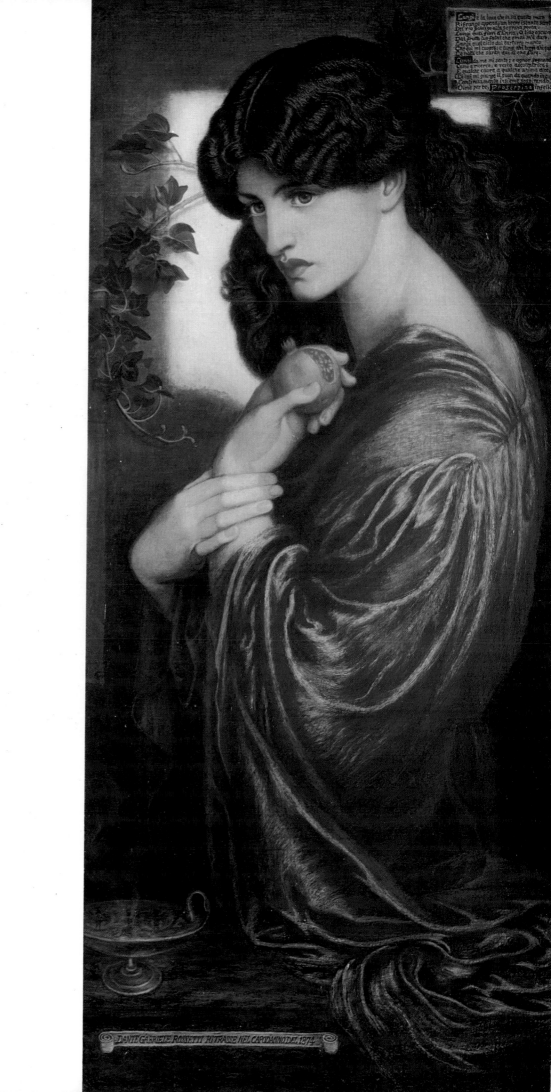

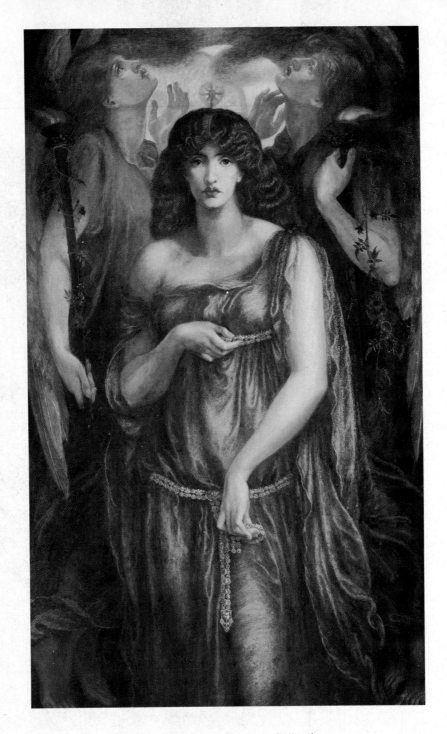

Astarte Syriaca. 1877. (Manchester City Art Gallery)

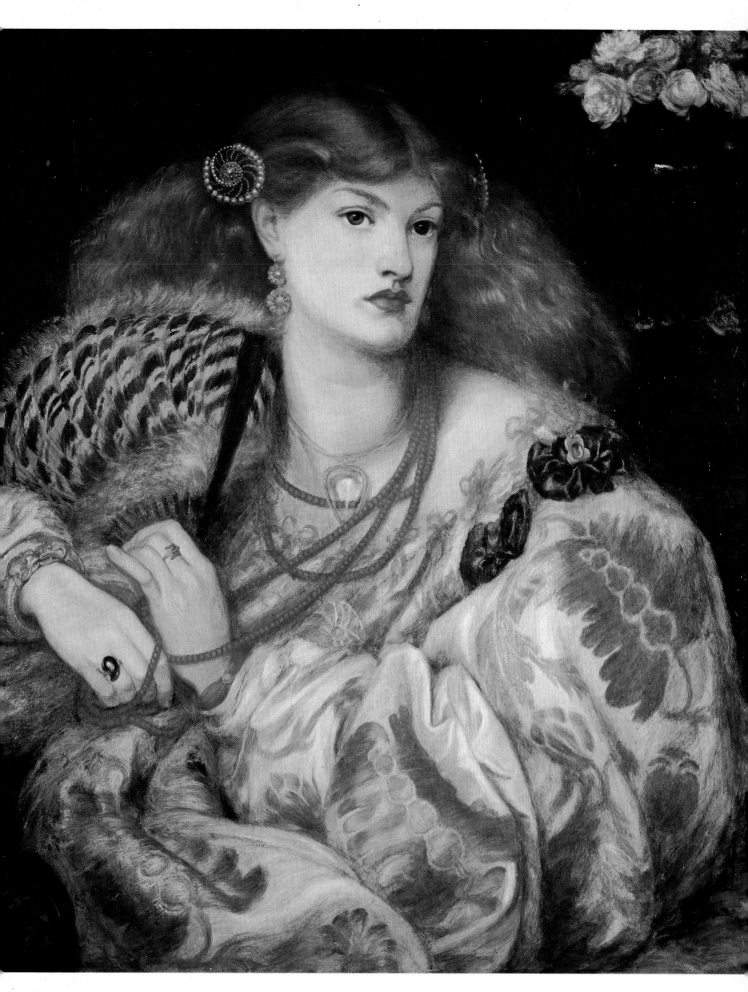

Monna Vanna. 1866. (The Tate Gallery)

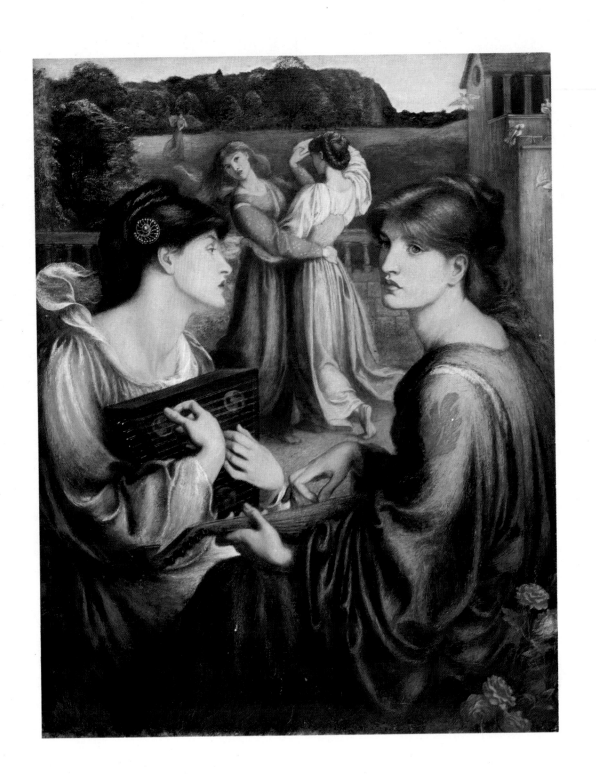

Study for **The Bower Meadow.** Black chalk over red chalk outline, 16⅜″ × 13⅝″, 1872. (*Birmingham City Museum and Art Gallery*)

Study for **The Bower Meadow.** Pen and brown ink, 4½″ × 3⅝″. (*Ashmolean Museum, Oxford*)

Previous page **Monna Vanna.** Oil, 35″ × 34″, 1866. (*The Tate Gallery, London*)

"I have a picture close on completion – one of my best I believe, and probably the most effective as a room decoration which I have ever painted. It is called *Venus Veneta,* and represents a Venetian lady in a rich dress of white and gold – in short the Venetian ideal of female beauty. It would be such a splendid match to your more classical Venus that I am induced to offer it you . . . ", Rossetti wrote to John Mitchell (who owned *Venus Verticordia,* the "more classical Venus") on 27th September, 1866. The *Venus Veneta* was renamed *Monna Vanna* and later, when retouched in 1873 at Kelmscott, *Belcolore.* Alexa Wilding sat for *Monna Vanna,* a name that occurs in Dante's *Vita Nuova.*

The Bower Meadow. Oil, 33½″ × 26½″, 1872. (*Manchester City Art Gallery*)

In 1850 Rossetti decided to paint the landscape background of his new project, *The Meeting of Dante and Beatrice in the Garden of Eden,* "from nature", and joined Holman Hunt and Frederick George Stephens in Knole Park, near Sevenoaks, for three rainy and windy weeks in November. Discouraged by the wet, uncomfortable reality of the adventure and unable to paint, he left the canvas unfinished until 22 years later when he transformed it into *The Bower Meadow.* Maria Spartali (Mrs. Stillman) is the woman on the left, Alexa Wilding is on the right.

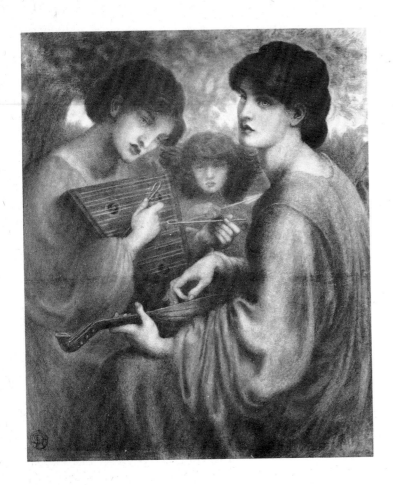

Study for **The Bower Meadow.** Pastel, 31″ × 26⅛″.
(*The Fitzwilliam Museum, Cambridge*)

THE SONG OF THE BOWER

Say, is it day, is it dusk in thy bower,
 Thou whom I long for, who longest for me?
Oh! be it light, be it night, 'tis Love's hour,
 Love's that is fettered as Love's that is free.
Free Love has leaped to that innermost chamber,
 Oh! the last time, and the hundred before:
Fettered Love, motionless, can but remember,
 Yet something that sighs from him passes the door.

Nay, but my heart when it flies to thy bower,
 What does it find there that knows it again?
There it must droop like a shower-beaten flower,
 Red at the rent core and dark with the rain.
Ah! yet what shelter is still shed above it,—
 What waters still image its leaves torn apart?
Thy soul is the shade that clings round it to love it,
 And tears are its mirror deep down in thy heart.

What were my prize, could I enter thy bower,
 This day, to-morrow, at eve or at morn?
Large lovely arms and a neck like a tower,
 Bosom then heaving that now lies forlorn.
Kindled with love-breath, (the sun's kiss is colder!)
 Thy sweetness all near me, so distant to-day;
My hand round thy neck and thy hand on my shoulder,
 My mouth to thy mouth as the world melts away.

What is it keeps me afar from thy bower,—
 My spirit, my body, so fain to be there?
Waters engulfing or fires that devour?—
 Earth heaped against me or death in the air?
Nay, but in day-dreams, for terror, for pity,
 The trees wave their heads with an omen to tell;
Nay, but in night-dreams, throughout the dark city,
 The hours, clashed together, lose count in the bell.

Shall I not one day remember thy bower,
 One day when all days are one day to me?—
Thinking, 'I stirred not, and yet had the power,'—
 Yearning, 'Ah God, if again it might be!'
Peace, peace! such a small lamp illumes, on this highway,
 So dimly so few steps in front of my feet,—
Yet shows me that her way is parted from my way
 Out of sight, beyond light, at what goal may we meet?

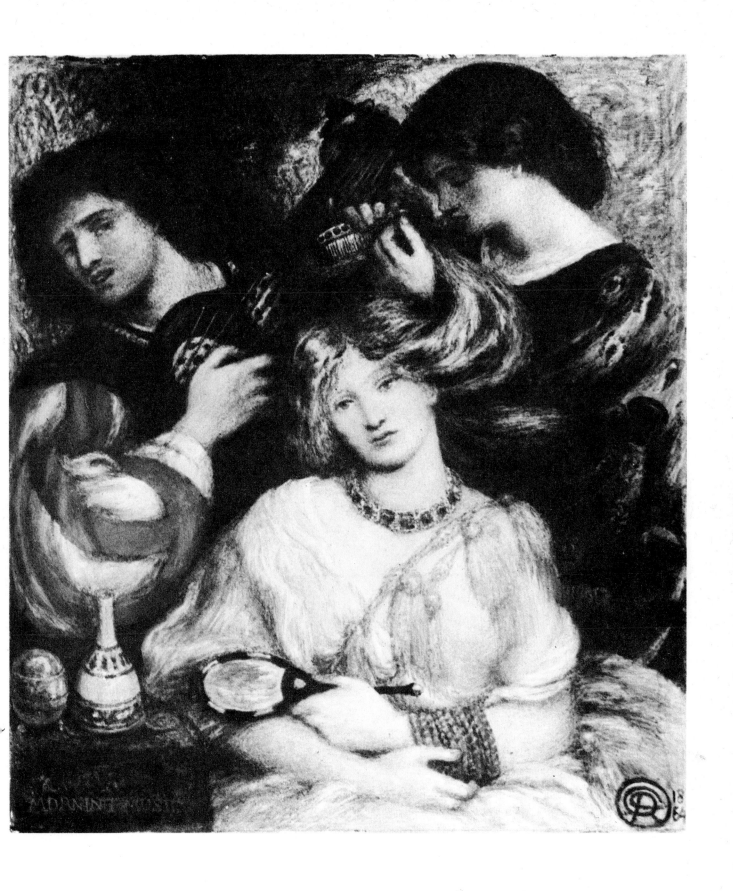

Morning Music. Water-colour, $11\frac{5}{8}'' \times 10\frac{1}{2}''$, 1864. (*The Fitzwilliam Museum, Cambridge*)

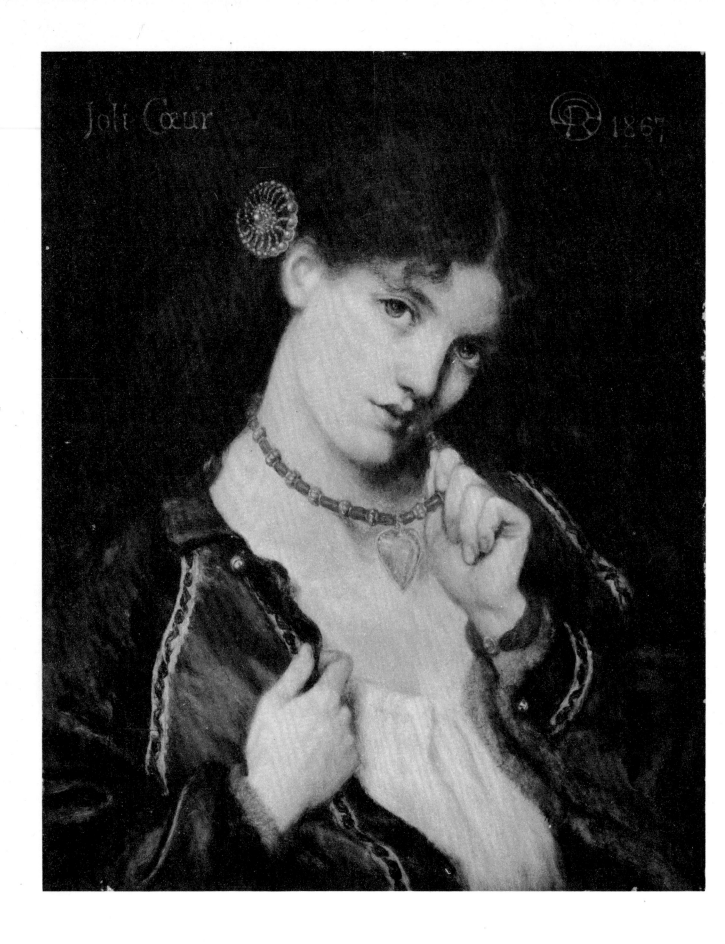

Joli Coeur. Oil on panel, 14¾″ × 11¾″, 1867. (*Manchester City Art Gallery*)

In 1867 Rossetti completed some twenty pictures, a year of tremendous artistic activity but also one of growing depression and social isolation. The model here is Ellen Smith.

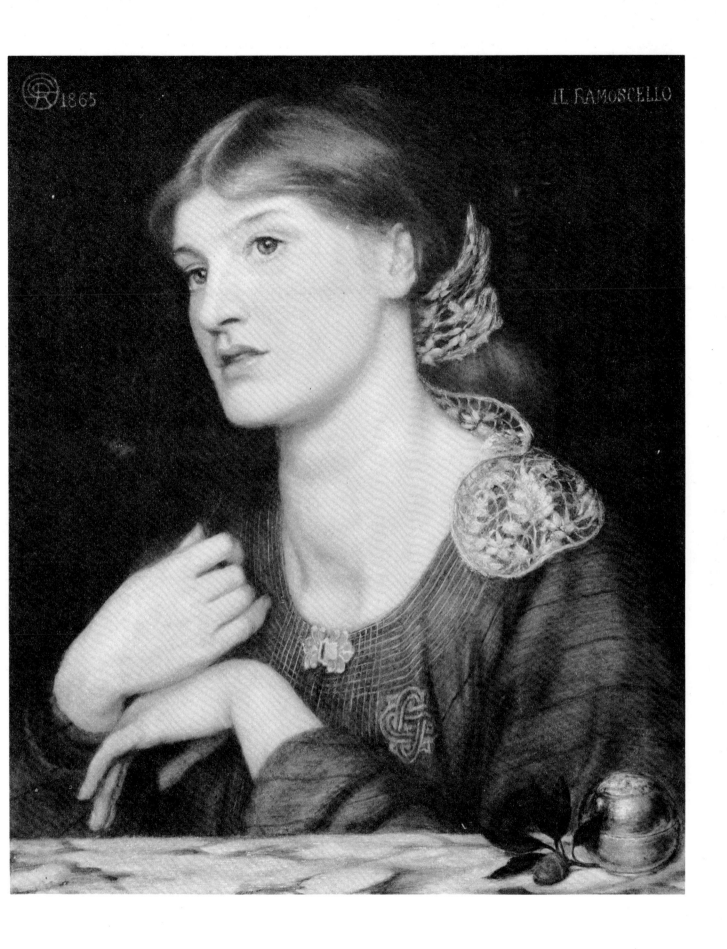

Il Ramoscello. Oil on panel, 18″ × 14½″, 1865. (*The Fogg Museum of Art, Harvard University*)

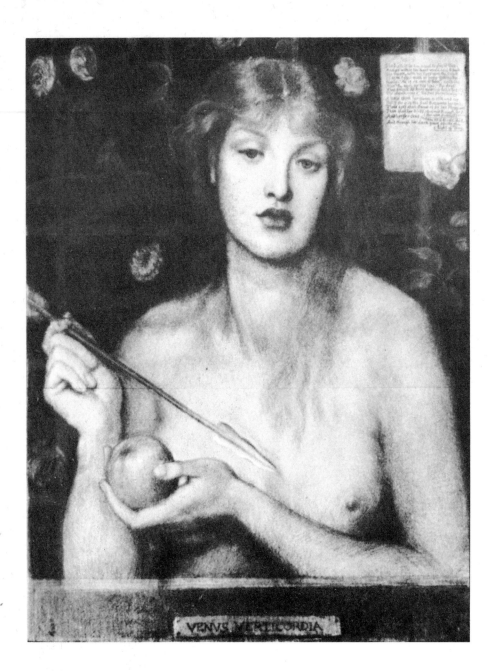

Study for **Venus Verticordia.** Red Chalk, 30½″ × 24⅜″, 1863. (*The Faringdon Collection, Buscot Park*)

Venus Verticordia.

William Michael Rossetti discussed the theory of Venus as the "Turner of Hearts" in a letter to his brother in 1869: "Lemprière makes a very startling statement: 'Venus was also surnamed . . . Verticordia because she could turn the hearts of women to cultivate chastity'. If this is at all correct, it is clear that the Verticordian Venus is, technically, just the contrary sort of Venus from the one you contemplate." The model for the 1863 chalk study was a cook Rossetti noticed in the street who was, according to William Allingham, nearly six feet tall, "almost a giantess". Alexa Wilding sat for Venus in the final version. As usual Rossetti, who so often painted flowers, had difficulty locating exactly what he wanted. On August 16, 1864 he wrote to his mother: "As for me, I have no chance of getting away just now, as I am tied down to my canvas till all the flower part of it is finished. I have done many more roses, and have established an arrangement with a nursery-gardener at Cheshunt, whereby they reach me every two days at 2s. 6d. for a couple of dozen each time, which is better than paying a shilling apiece at Cov[ent] Garden. Also honeysuckles I have succeeded in getting at the Crystal Palace, and have painted a lot already in my foreground, and hope for more. All these achievements were made only with infinite labour on my part, and the loss of nearly a whole week in searching. But the picture gets on well now."

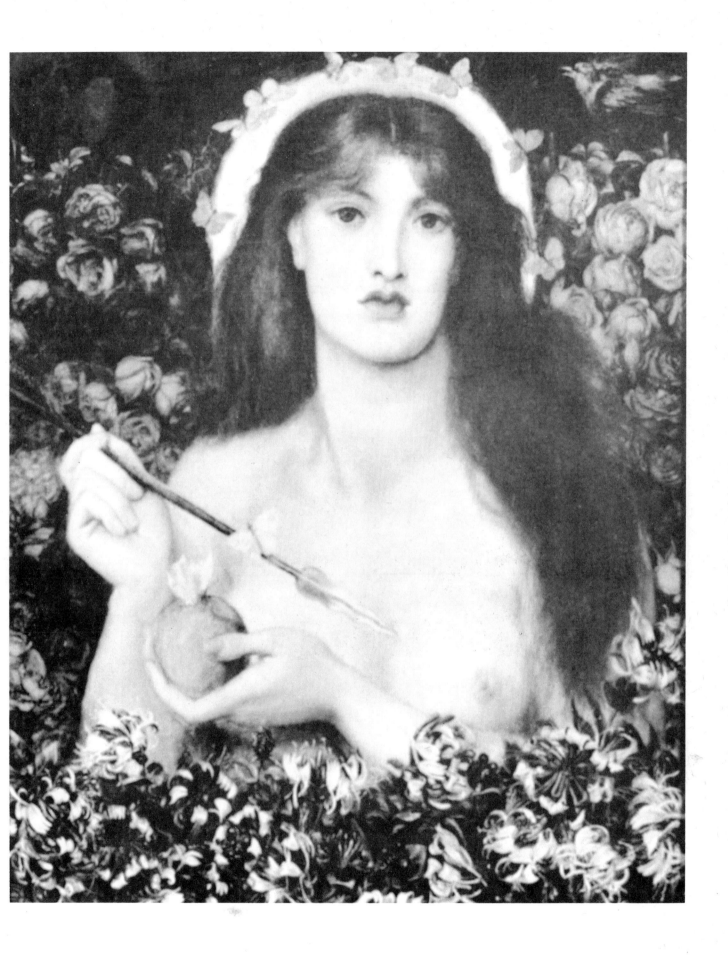

Venus Verticordia. Oil, 38⅝″ × 27½″, 1864–8. (*Russell-Cotes Art Gallery and Museum, Bournemouth*)

'FOUND'

(For a Picture)

'There is a budding morrow in midnight:'—
 So sang our Keats, our English nightingale.
 And here, as lamps across the bride turn pale
In London's smokeless resurrection-light,
Dark breaks to dawn. But o'er the deadly blight
 Of love deflowered and sorrow of none avail
 Which makes this man gasp and this woman quail,
Can day from darkness ever again take flight?
Ah! gave not these two hearts their mutual pledge,
Under one mantle sheltered 'neath the hedge
 In gloaming courtship? And O God! to-day
He only knows he holds her;—but what part
Can like now take? She cries in her locked heart,—
 'Leave me—I do not know you—go away!'

1881

Rossetti's "modern picture", his only painting with an overtly moral theme, was begun in 1854 and never completed. He worked on it intermittently until his death but found the realistic subject incompatible and could not master the perspective. Fanny Cornforth modelled for the prostitute found by the farmer who was once in love with her. Rossetti painted the wall from one in Chiswick and the calf and cart in Finchley near the Madox Browns'. He spent much of the winter of 1854 there, laboriously copying the animal and imposing on the penniless Browns who, in desperation, eventually asked him to leave. The painting was repeatedly commissioned, not completed and then recommissioned, Rossetti demanding an advance payment with each new promise. Some of the landscape and sky was done by his assistant Dunn and by Burne-Jones. The interminable challenge this picture presented can be seen in the following selections from his letters. In November, 1854, writing to William Allingham from Finchley during the early stages of work on the canvas, Rossetti was able to be amused at the difficulties of realistic painting: "At present I am hard at work out here on my picture, painting the calf and cart. It has been fine clear weather, though cold, till now, but these two days the rain has set in (for good, I fear), and driven me to my wit's end, as even were I inclined to paint notwithstanding, the calf would be like a hearth-rug after half an hour's rain; but I suppose I must turn out tomorrow and try. A very disagreeable part of the business is that I am being obliged to a farmer whom I cannot pay for his trouble in providing calf and all, as he insists on being goodnatured. As for the calf, he kicks and fights all the time he remains tied up, which is five or six hours daily, and the view of life induced at his early age by experience in art appears to be so melancholy that he punctually attempts suicide by hanging himself at 3½ daily P.M. At these times I have to cut him down and then shake him up and lick him like blazes. There is a pleasure in it my dear fellow: the Smithfield drovers are a kind of opium-eaters at it, but a moderate practitioner might perhaps sustain an argument." Fifteen years later, in December, 1869, the picture was still unfinished and Rossetti was still determined, though hardly cheerful, when he wrote to Frederic James Shields: "For many months I have done no painting or drawing, but have just lately resumed work of this kind, and am proceeding as best I may against the stream of models, who cannot be got or do not come, pitch black days, etc., with such things as I want to be doing. These are chiefly the large pictures of *Dante's Dream* . . and (!!!) the old picture of *Found* (the calf and bridge subject), which I am actually taking up at last. I have lots of time as yet in preliminary studies for both works; but hope to get the man's head done in the *Found* next week, having found a splendid model, and have also made considerable way towards the bridge background. Had I a large fine studio, I should now get all my finest subjects squared out from the designs on canvases of the size needed, and taken them all up one after the other whenever possible. This plan I shall pursue vigorously more or less now, as life wears short, and do I trust few single pictures except when shut out from other work by the chances of the hour." In May, 1879, to William Graham, his patron, Rossetti wrote of the picture in terms of its central meaning to him, that of proving his ability to "paint from nature", the original tenet of the Pre-Raphaelite Brotherhood: "I have lately again taken up the *Found* and also in order to (achieve) the successful putting together of its rather varied parts, am making a full-sized mono-chrome design of it; as I found that without this, the perspective and other points are difficult to manage successfully . . . I referred to it above as one without which I should not attempt an exhibition on account of its furnishing a refutation (I trust) to what is so often alleged against poetic painting such as I follow commonly to the best of my ability – I mean the charge that a painter adopts the poetic style simply because he cannot deal with what is real and human. I should wish to show – as such a picture as *Found* though small, must do, if I succeed with it – that my preference of the ideal does not depend on incapacity to deal with a simple nature."

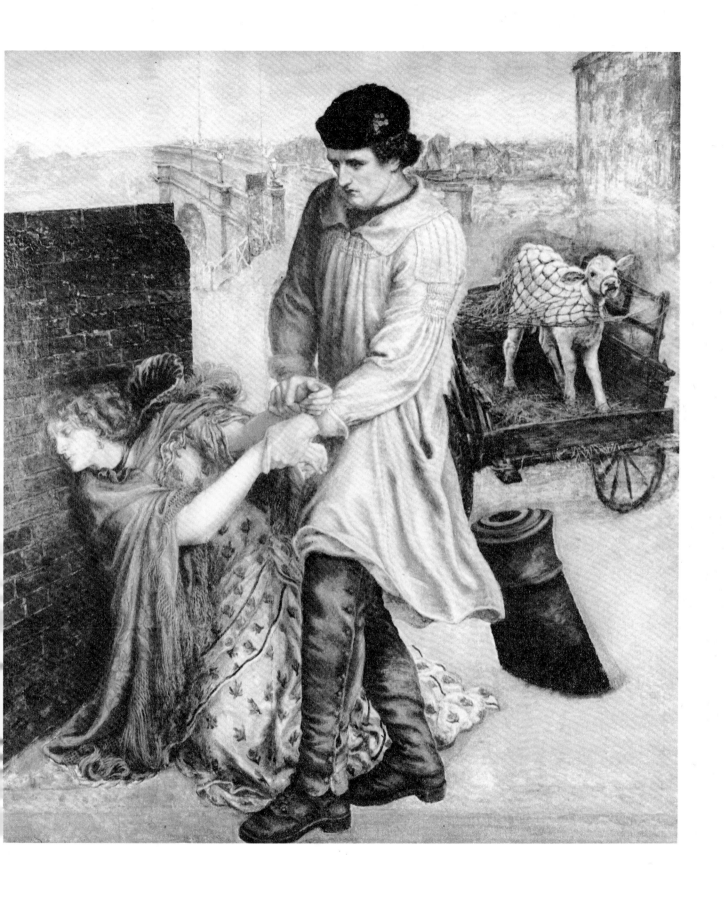

Found. Oil, 36″ × 31½″, begun 1854. (*Samuel and Mary R. Bancroft Collection, Delaware Art Museum*)

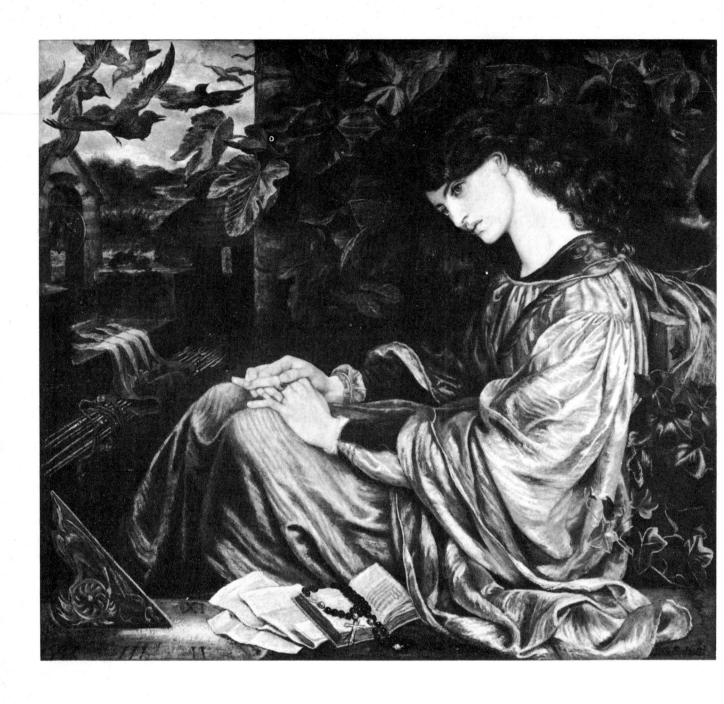

La Pia de' Tolomei. Oil, 41½" × 47½", 1868–80. (*The Univerity of Kansas Museum of Art, Lawrence, Kansas*)

The chalk study of Alexa Wilding (p.6) was done in 1868 and later that year Mrs. Morris began to sit, but the painting itself was not finished until 1880. La Pia was confined to a fortress in the marshes of Marrema by her husband and died there a prisoner, without receiving absolution. The words her suffering spirit speaks to Dante in the fifth Canto of *Purgatorio* are quoted on the painting's frame:

"Ah! when on earth thy voice again is heard,
And thou from the long road hast rested thee
(After the second spirit said the third),
Remember me who am La Pia; me
Siena, me Maremma, made, unmade,
This in his inmost heart well knoweth he
With those fair jewel I was ringed and wed."

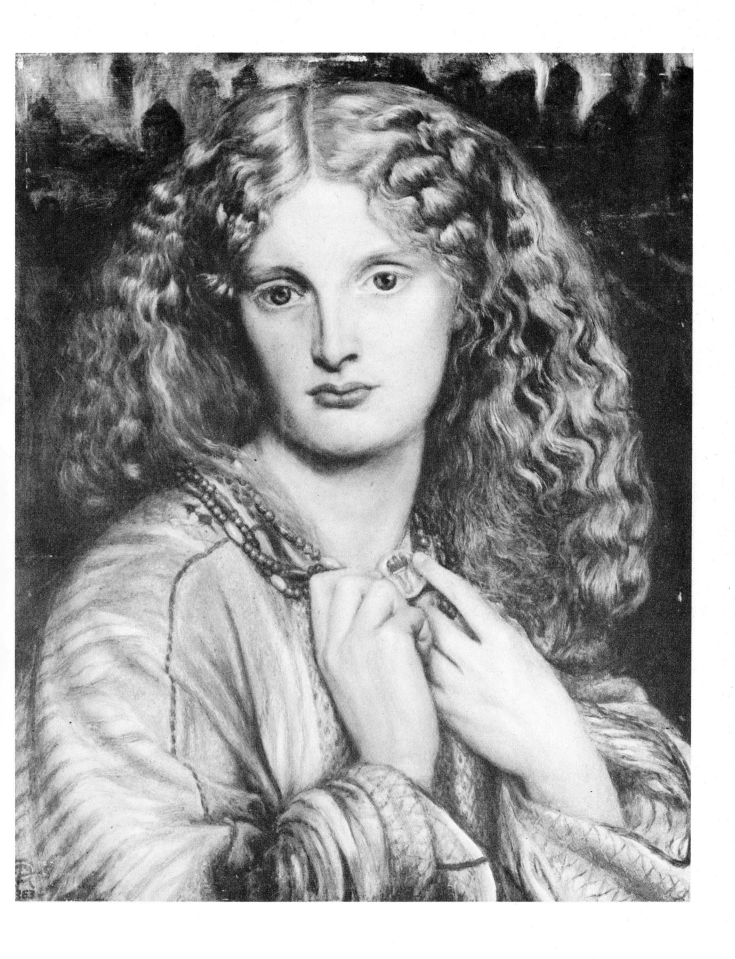

Helen of Troy. Oil on panel, 12¼" × 10½", 1863. (*Kunsthalle, Hamburg*)

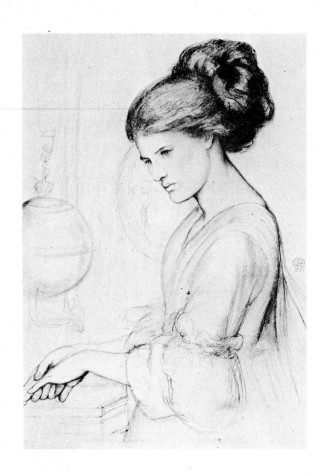

Study for **Washing Hands.** Pencil, 18″ × 13¾″, 1865.
(*The Fitzwilliam Museum, Cambridge*)

A study for a lost water-colour, described by Rossetti as follows: "The design represents the last stage of an unlucky love affair. The lady has gone behind the screen (in the dining room perhaps) to wash her hands; and the gentleman, her lover, has followed her there, and has still something to say, but she has made up her mind. We may suppose that others are present, and that this is his only chance of speaking. I mean it to represent that stage of a courtship when both of the parties have come to see in reality that it will never do, but when the lady, I think, is generally the first to have the strength to act on such knowledge. It is all over, in my picture, and she is washing her hands of it." The woman was painted from Ellen Smith, the man from Charles Augustus Howell, Ruskin's secretary.

La Donna della Finestra. Oil, 39½″ × 29″, 1879. (*The Fogg Museum of Art, Harvard University*)

Rossetti painted Jane Morris as "The Lady of Pity" of the *Vita Nuova* who gazed down sympathetically from a window at the suffering Dante. Rossetti believed the woman to be Gemma Donati, Dante's future wife, giving her a more concrete identity than she is generally considered to have (in the usual allegorical interpretation she is thought to represent "Philosophy"). In his book *D.G. Rossetti as a Designer and Writer*, W.M. Rossetti commented on his brother's ability and need to endow the abstract or symbolic with the characteristics of external reality: "Humanly she is the Lady at the Window; mentally she is the Lady of Pity. This interpretation of soul and body – this sense of an equal and indefeasible reality of the things symbolized, and the form which conveys the symbol – this externalism and internalism – are constantly to be understood as the key-note of Rossetti's aim and performance in art." Rossetti began making studies of Mrs. Morris for the picture in 1870, but the work was not completed until 1879. He grew less enthusiastic about it as he finished it, in the end finding it valuable mostly for the sake of the sitter "to whom I owe the best of my art such as it is".

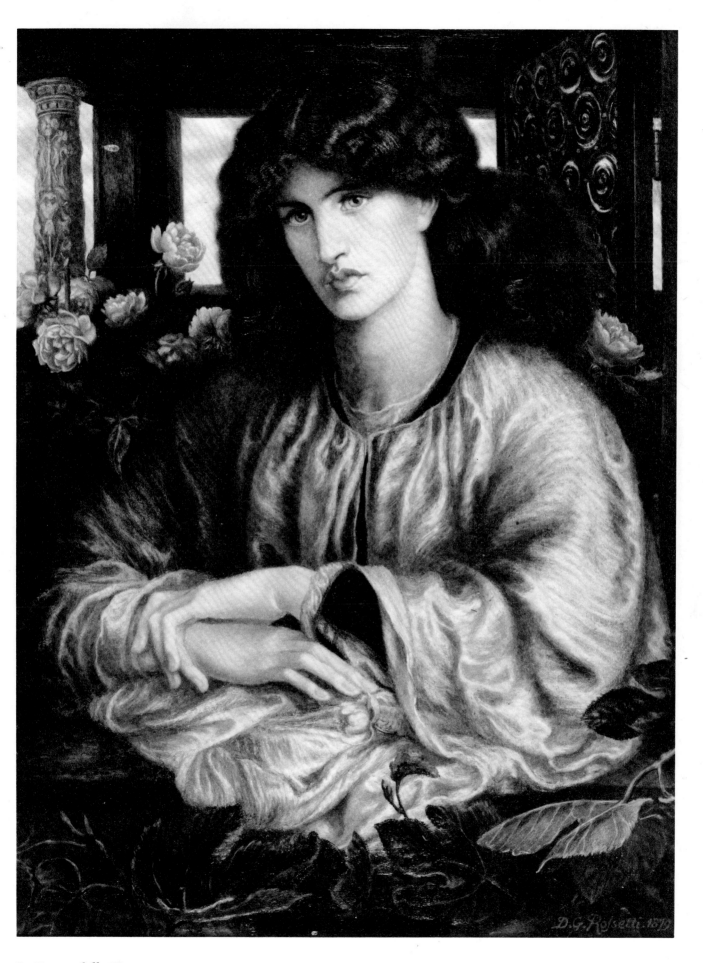

La Donna della Finestra

Mr. Rossetti exhibits his pictures in his studio and on the walls of his employers—nowhere else. Whether a painter exhibits his productions or not is a matter for his own judgment; exhibition is merely an incident in the existence of a picture; ordinarily speaking, it is a serviceable test of its value. Of late, the artist in question has, to some extent, resumed the practice of oil-painting; the results we have now to describe, in the hope that the public may, ere long, be able to judge for itself of the order of their invention, originality and technical merit. The scale of the pictures is almost that of life.

The most original, and, probably, the most important in technical respects, of these pictures is styled *The Blue Bower*. Of this, as of others, we must premise that it is of the nature of a lyrical poem, which aims at effect quite as much by means of inherent beauty and melodious colouring as by the mere subject, which is superficial. Titian and Giorgione produced lyrics of this sort in abundance; many of their pictures are nothing if not lyrical. In this direction English Art has not yet ventured far. Mr. Rossetti long ago saw the road which was thus presented, and pursued it to a most felicitous result. *The Blue Bower* depends in its appeal to the observer on its poetical spirit,—and to the master of matters technical, as well as to the mind which is habituated to such phases of pictorial power, on its exquisite feeling for colour and delicacy of expression. In these qualities the picture before us is triumphant. To the eyes of the former class of students it represents a lady playing on a dulcimer that lies upon a table; over the strings her fingers stray, eliciting sounds which are now loud, now low, and seem to murmur all about her. The fingers of the left hand retain the sound of the dulcimer, while those of the right, with the thumb, produce the music. She listens to the floating sound and accordant notes; to do so easily her hair is removed from the shell of the delighted ear; her lips are just apart, for the escape of the soft breath; her eyes are softly veiled by levelled lids, and seem attending, in perfect unison with the ears. Solid masses of hair, coloured like the inside of a chestnut rind, that is, a greyish, golden brown, with sparks of light, hang dishevelled about her face, heap on her shoulders and pass in abundance to her back; a great pin, or aigrette, of gold, studded with pale turquoises and a sanguine carbuncle keeps it from before the ear. Her throat is bare; masses of white fur cover the bosom; with this material the whole of her robe is lined; that robe wraps her shoulders, and is of a deep, watery green, bound with black and buttoned with gold. Passion-flowers, whose purple discs are backed by white petals, trail with dark-green leaves on either side of the figure, and are entwined with the paler foliage and bell-shaped flowers of the wild convolvulus.

The picture derives its name from the background of blue wall-tiles, which, in oriental fashion, line the apartment where the lady is, and are patterned with that perfect harmony of white which is so well understood in the East. Beyond this, so indefinite is the work, there is nothing to suggest subject, time, or place. Where we thus leave off, the intellectual and purely artistic splendour of the picture begins to develope itself. The music of the dulcimer passes out of the spectator's cognizance when the chromatic harmony takes its place in appealing to the eye. The blue of the wall finds its highest and most powerful key-note in the superb corn-flowers that lie in front of the instrument; the hue of both is echoed by the turquoises of the aigrette. The green and chestnut-auburn, the pallid roses of the flesh, and the firmamental blue of the background, are as ineffable in variety of tint as in their delicious harmony. The green is as deep and almost as translucent as that of the sea when the sun fills it with light. The sharp notes of the picture are in the black of the dulcimer, and that which runs a zigzag on the border of the robe, as well as in what may be called the stridulous accent of the red which is supplied by the tassel of the instrument. More subtle harmonies than the above are indescribable. The woman is beautiful in no common way; but her air more powerfully entrances us to sympathy with her act of slowly drawing luxurious music from the strings, so that the eyes and the ear of fancy go together. Then we have the marvellous fleshiness of the flesh; the fascinating sensuousness of the expression, which is refined, if not elevated, by the influence of the music. The wealth, no less than the cunning combination and ample variety of the colour, will delight the student and those who are content to receive a picture in the spirit which is proper to the highest form of Art, whether it be developed in painting, sculpture, music, or architectural design.

From The Athenaeum, *October 21, 1865.*

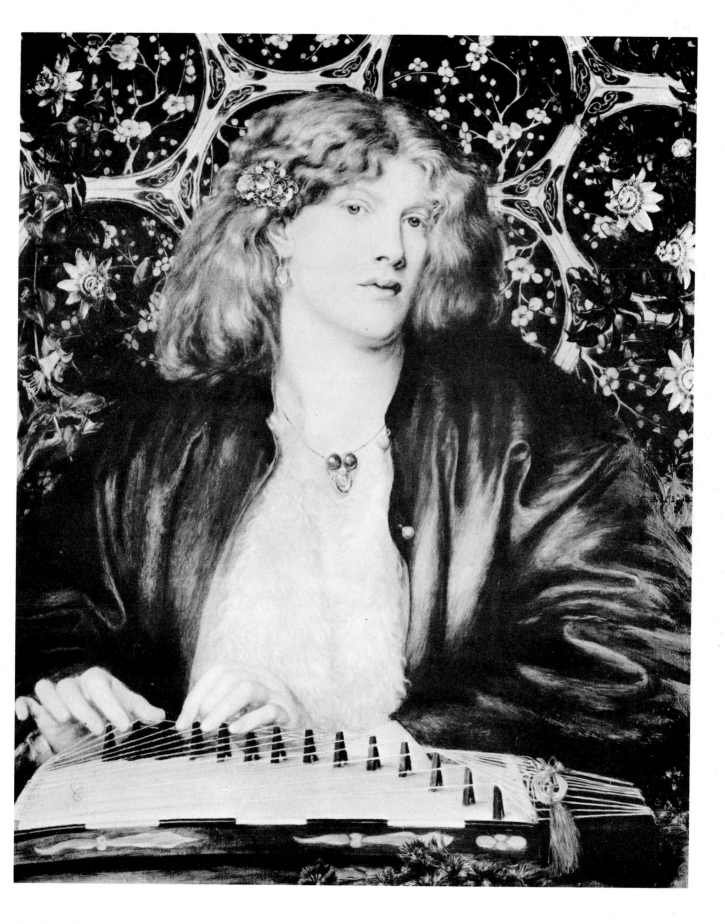

The Blue Bower. Oil, $35\frac{1}{2}'' \times 27\frac{1}{4}''$, 1865. (*The Barber Institute of Fine Arts, University of Birmingham*)

George Stephens admired this painting in his *Athenaeum* review of 1865 for "the marvellous fleshiness of the flesh". Buchanan was later to take up this phrase in his famous attack on Rossetti. The sitter is Fanny Cornforth.

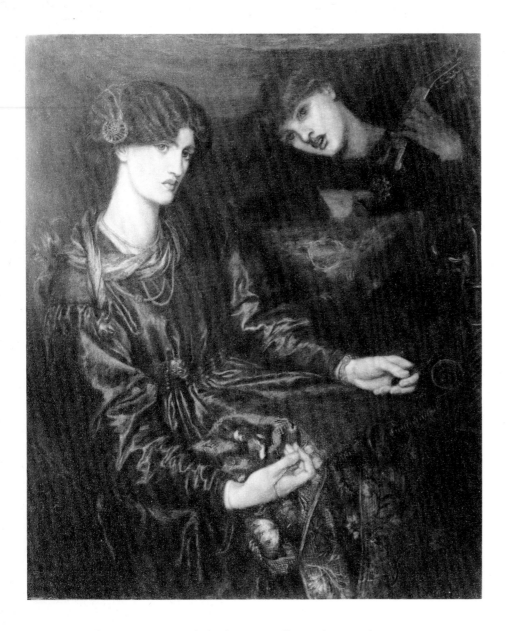

Mariana. Oil, 43″×35″, 1870. (*Aberdeen Art Gallery and Museum*)

In this illustration of the opening of Act IV of *Measure for Measure* Mrs. Morris, as Mariana, listens to the words of the song, inscribed on the frame, "Take, O take, those lips away".

La Ghirlandata

La Ghirlandata was painted in the summer of 1873 at Kelmscott, the house shared by Morris and Rossetti. May Morris, the Morrises' daughter, modelled for the angel heads. The sitter was Alexa Wilding who, from 1866 to 1877, shared with Mrs. Morris the position of being Rossetti's favourite model. Rossetti encountered her in the street in 1864 and she was paid a retaining fee to keep her exclusively in his service. Writing to his mother in May, 1873, Rossetti was concerned with his family's reaction to "poor Miss W." "Would it suit you and Christina to be coming here *at once* if I found that feasible? And could Maria come? In a day or two I shall be able to settle About the model, it would be Miss Wilding, who is a *really* good creature, fit company for anyone, and quite ladylike, only not gifted or amusing. Thus she might bore at meals and so on (for one cannot put her in a cupboard) and this question might restrict my powers as to the time of inviting you. There is also Brown and wife whom I want to get down, and Dr. Hake also – but of course there would be no need of doing things in a hurry unless you thought that the presence of others might make poor Miss W. more bearable. Let me know. You see, out here one has to live with one's models as they cannot come to sit and then go home. But she is the most retiring and least self asserting of creatures and would not be much in the way, at least not more than was unavoidable."

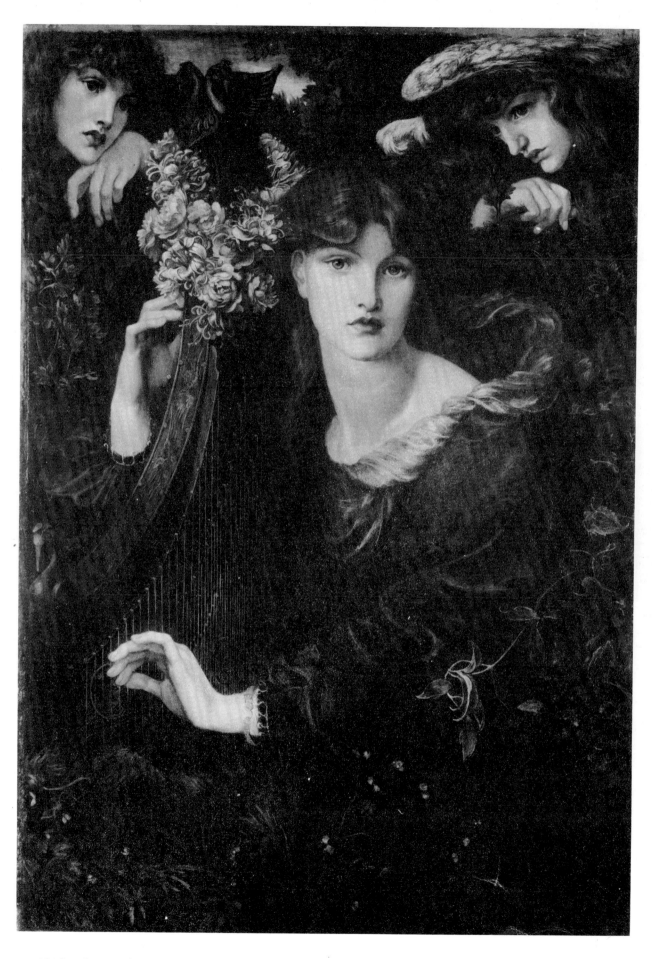

La Ghirlandata. Oil, 45½″ × 34½″, 1873. (*Guildhall Art Gallery, London*)

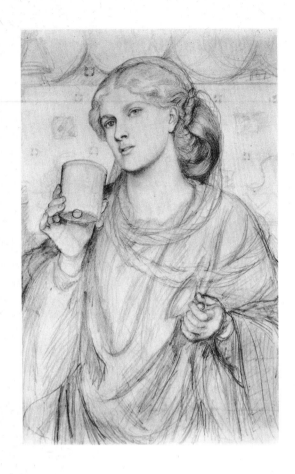

Study for **The Loving Cup.** Pencil, 20″ × 14″, c. 1867.
(*Birmingham City Museum and Art Gallery*)

La Bella Mano

Painted in Tudor House, Cheyne Walk, during the year after Rossetti left Kelmscott Manor. The woman is Alexa Wilding, the angel with the tray probably May Morris. In 1874 Rossetti wrote to Thomas Gordon Hake, his physician, " . . . I am now engaged on a picture to be called *La Bella Mano*. It is a good-sized Titianesque subject – a girl washing her hands with two attendant Cupids – and will, I hope for flesh painting and general painter's qualities, surpass any picture of mine of that sensuous realistic type."

From The Athenaeum, *August* 14, 1875.

La Bella Mano is the title of the next work,—a title which may remind Italian readers of the well-known Petrarchian series of sonnets, so named, by Giusto de' Conti. The picture is, however, simply a painter's fancy, and almost entirely dependent on pictorial qualities. It belongs to what may be called, on one account, at least, the class of toilette pictures, where the Lady, or Venus, has her attendant Loves. Here the Lady is washing her hands at a cistern and basin of brass, while two white-robed and red-winged Loves are in attendance, one holding the towel in readiness, the other having on a silver tray the adornments destined for her "bella mano." A mirror behind her head reflects the room and bed; these elements are deep in tone; a fire is burning in the chimney nook. The pictorial object of this work has been to show the brilliancy of flesh-tints and whites, relieved on a ground subdued to the eye, and yet everywhere replete with varied colour and material. In these respects the work is a marvel of art, the whole glowing with rich light, and being intensely deep in tone, wealthy in colour. The sentiment of the design lies in the face, and is discoverable in the light of a woman's hope which fills the eyes, has given a warmer rose tint to the full and slightly-parted lips, that are red in their vitality, and as the abundant, noble bosom is, voluptuous, not luscious. The face is slightly raised, and put sideways towards us, the figure standing in profile, so that the masses of deep golden hair which project from her brow cast shadows on the upper part of the face. Her dress is a dark marone, with a scarf of a lighter tint of the same hue. The figure is of a large life-size; the style of the drawing, noticeable in the contours of the head, the arms, and the hands, is large and grand. The picture derives wonderful force of effect from the deep tone which pervades it, and has rare success in rendering the interior light, which, contrasting with the light of *Proserpina*, is very warm and rich.

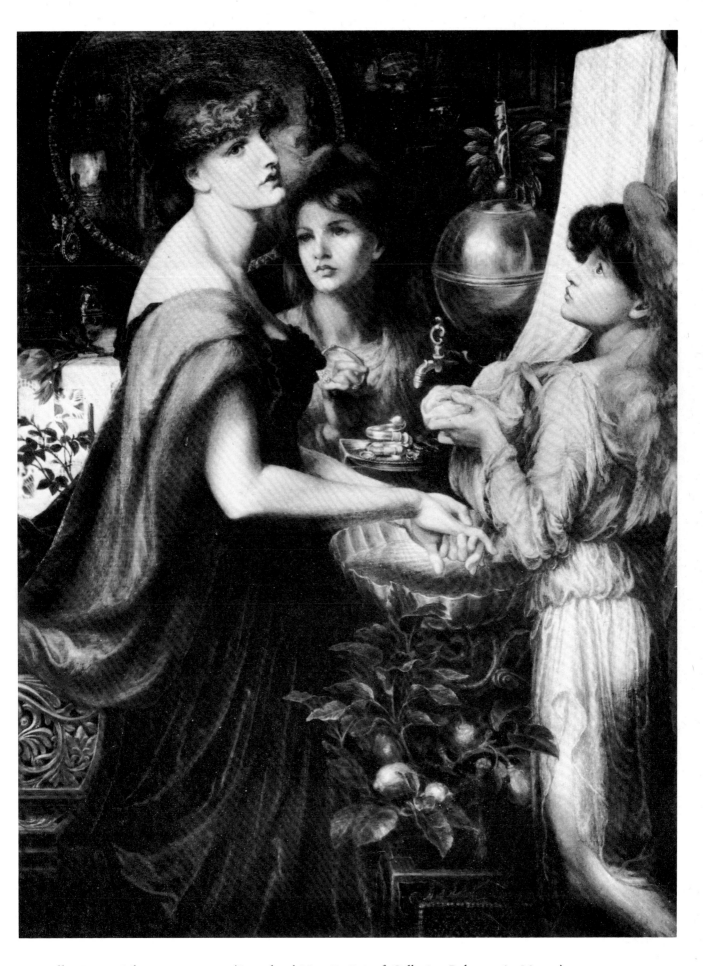

La Bella Mano. Oil, 62″×42″, 1875. (*Samuel and Mary R. Bancroft Collection, Delaware Art Museum*)

A

SEA-SPELL

(For a Picture)

Her lute hangs shadowed in the apple-tree
 While flashing fingers weave the sweet-strung spell
 Between its chords; and as the wild notes swell,
The sea-bird for those branches leaves the sea.
But to what sound her listening ear stoops she?
 What netherworld gulf-whispers doth she hear,
 In answering echoes from what planisphere,
Along the wind, along the estuary?

She sinks into her spell: and when full soon
 Her lips move and she soars into her song,
 What creatures of the midmost main shall throng
In furrowed surf-clouds to the summoning rune:
 Till he, the fated mariner, hears her cry,
 And up her rock, bare-breasted, comes to die?

1881

A Sea Spell.

Originally intended as a companion picture to *Veronica Veronese,* the painting illustrates the lines from Coleridge's *Kubla Khan:* "A damsel with a dulcimer/ In a vision once I saw". The model is Alexa Wilding. *Veronica Veronese* had been painted for Frederick Leyland. In August, 1875 Rossetti wrote to him in the hope of obtaining an offer for the recently begun *Sea Spell,* explaining that it "is as brilliant in painting as anything I have done or can do It represents the lady (Miss W) seated by a tree on which her instrument is hung, and playing on it in an attitude of passionate absorption, while her hair spreads wide over the bough above her, and a dove in the tree stretches its neck low along the branch, with its wings raised, and listens to the magic lay. Thus here the bird listens to the player, as in the other picture the player does to the bird."

From The Athenaeum, *April* 14, 1877.

The siren, a full-sized figure, sits bowing before a two-stringed lute-like instrument, of antique form, which rests upright before her, partly suspended from the boughs of a huge tree in full leaf. Over her head is a white sea-bird, which, attracted by the melody the siren has "woven" with the strings, rushes through the air to listen. Beyond are glimpses of a sunlit ocean, and blue firmament, vividly lighted. The siren stoops, her face brought low and turned nearly in full towards us, and looking as in a half-dream under the influence of some compelling power, heeding her own music with abstracted eyes, and with the vague witchery of a smile set on her ruddy lips; her hands touch, or rather, seem to unite with the chords, producing the melody. Her skin is brilliant and rosy: indeed, there is an inner-glowing rosiness which is enchantingly fair. Her long, bent neck and her ample bosom are left bare by the abundance of a dress of pale, silvery, bronze-hued tissue, having the sheen of fine silk on its loose, wave-like folds, that seem to ripple about her form, revealing her full torso; her knees are bent as if she swung herself in the cadence of the chanted spell. Her long, fair arms are bent at the elbows diversely, and her pliant fingers seem to move in unison with the suggested weaving of the charm. This pose is most gracefully expressed, and admirable in its originality and peculiar grace. Masses of deep, ruddy, golden hair flow from under a great garland of blush roses, and, sweeping behind her shoulders, roll heavily on her back.

The colour of this picture has an especial charm in complete harmony with the theme, a rosy witchery illumines it, and it assorts perfectly with the powerful chiaroscuro of a large illumination shining over all the work. The local tint of the dress is superbly fine and delicate, yet intensely powerful, going with the golden hair, the freshness of the rosy carnations, the vivid green of the foliage and the darker tone of the lute. By her side stand tall red flowers of the antirrhinum, or Venus Fly-Trap; she sits on a rock. The beauty of the half-tones is magical, almost Titianesque in its refinement and completeness. As the *Proserpine* excels in an intense contrast of strong lights and shadows, thus suiting the subject, and the mystic beauty of *Venus Astarte* is in harmony with its sumptuous colouring and fervid splendours of sun and moon and torchlight in a large measure of profoundly toned shadows, so the *Siren* sits in wealth of splendid sunlight, without a dark shadow, of the clearest illumination, distinct in the purest day, of the sea shore.

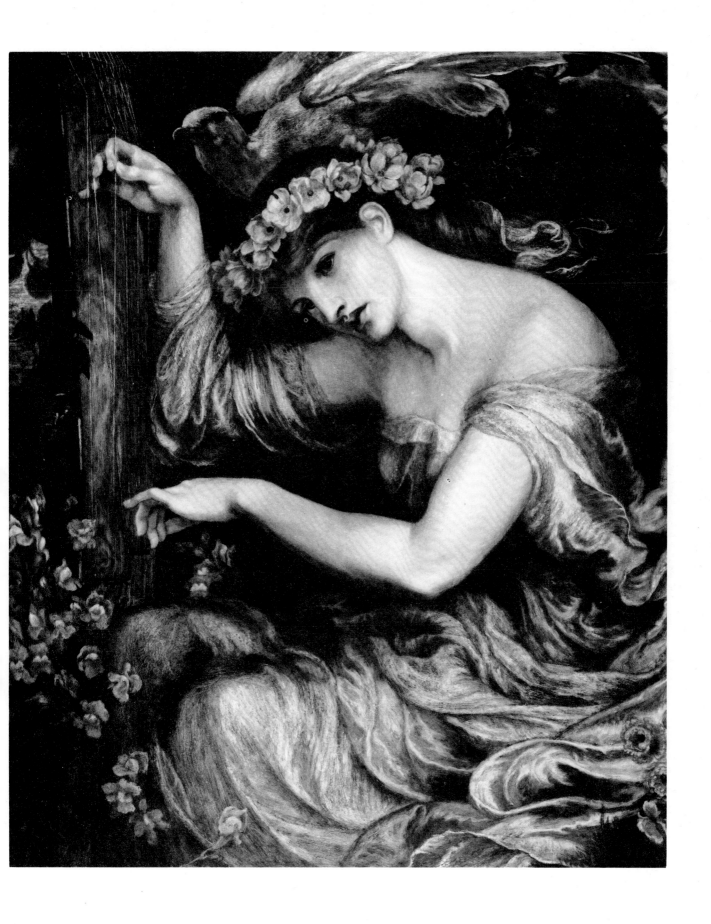

A Sea Spell. Oil, 43″ × 35¾″, 1877. (*The Fogg Museum of Art, Harvard University*)

The Question. Pencil, 18¾″ × 16″, 1875. (*Birmingham City Museum and Art Gallery*)

A highly symbolic composition for a painting that was never executed, *The Question* was a response to the death of Oliver Madox Brown in 1874. The nineteen year old Oliver, whom Rossetti had been encouraging in writing and painting, was the son of Ford Madox Brown, Rossetti's closest friend, and Emma Brown, Elizabeth Siddal's loyal supporter. The death came as a deep shock to Rossetti and the "question" here illustrated is Shakespeare's "To be or not to be".

INDEX

BIBLIOGRAPHY

A Selected Bibliography of works on Dante Gabriel Rossetti and the Pre-Raphaelite movement.

Doughty, Oswald and Wahl, John Robert, editors. *The Letters of Dante Gabriel Rossetti*. Oxford: The Clarendon Press. Volumes 1 and 2, 1965. Volumes 3 and 4, 1967.

Doughty, Oswald, editor. *Dante Gabriel Rossetti: Poems*. London: Dent, 1965.

Doughty, Oswald. *A Victorian Romantic: Dante Gabriel Rossetti*. London: Oxford University Press, 1960.

Fredeman, William E. *Pre-Raphaelitism: A Bibliocritical Study*. Cambridge, Massachusetts: Harvard University Press, 1965.

Gaunt, William. *Rossetti*. 'The Masters' Volume 89. London: Knowledge Publications, 1967.

Hilton, Timothy. *The Pre-Raphaelites*. London: Thames and Hudson, 1970.

Hueffer, Ford Madox. *The Pre-Raphaelite Brotherhood: A Critical Monograph*. London: Duckworth, 1907.

Hueffer, Ford Madox. *Rossetti: A Critical Essay on His Art*. London: Longmans, 1896.

Hunt, John Dixon. *The Pre-Raphaelite Imagination 1848–1900*. London: Routledge and Kegan Paul Ltd., 1968.

Hunt, William Holman. *Pre-Raphaelitism and the Pre-Raphaelite Brotherhood*. Two volumes. London: Macmillan, 1905–1906.

Marillier, Henry Currie. *Dante Gabriel Rossetti: An Illustrated Memorial of His Art and Life*. London: Bell, 1899.

Rossetti, Dante Gabriel. *Dante's Vita Nuova*. London: George Routledge & Sons Ltd., n.d.

Rossetti, William Michael. *Dante Gabriel Rossetti as Designer and Writer*. London: Cassell, 1889.

Rossetti, William Michael, editor. *The Works of Dante Gabriel Rossetti*. Revised and enlarged edition. London: Ellis, 1911.

Ruskin, John. *Arrows of the Chace, Being a Collection of Scattered Letters Published Chiefly in the Daily Newspapers*. Two volumes. London: Allen, 1880.

Ruskin, John, *Pre-Raphaelitism: By the Author of 'Modern Painters'*. London: Smith, Elder, 1851.

Surtees, Virginia. *The Paintings and Drawings of Dante Gabriel Rossetti 1828–1882: A Catalogue Raisonné*. Oxford: The Clarendon Press, 1971.

Watkinson, Raymond. *Pre-Raphaelite Art and Design*. London: Studio Vista, 1970.

The Germ: Thoughts towards Nature in Poetry, Literature and Art. Numbers 1 and 2, January and February, 1850. Continued as *Art and Poetry, Being Thoughts towards Nature, Conducted Principally by Artists*. Numbers 3 and 4, March and April, 1850. A facsimile reprint. New York: Ams Press, Inc., 1965.

Dante Gabriel Rossetti: Painter and Poet. Catalogue of an exhibition held at the Royal Academy of Arts 13 January - 11 March, 1973. London: The Royal Academy of Arts, 1973.